CANVAS REM1X

Alisa Burke

NORTH LIGHT BOOKS
Cincinnati, Ohio

www.mycraftivity.com

12 11 10 09 08 5 4 3 2 1

Distributed in Canada by Fraser Direct
100 Armstrong Avenue
Georgetown, ON, Canada L7G 5S4
Tel: (905) 877-4411

Distributed in the U.K. and Europe
by David & Charles Brunel House,
Newton Abbot, Devon, TQ12 4PU, England
Tel: (+44) 1626 323200, Fax: (+44) 1626 323319
E-mail: postmaster@davidandcharles.co.uk

Distributed in Australia by Capricorn Link
P.O. Box 704, S. Windsor, NSW 2756, Australia

Tel: (02) 4577-3555

Library of Congress Cataloging-in-Publication Data

Burke, Alisa.
 Canvas remix : techniques for creating mixed-media accessories
/ by Alisa Burke. -- 1st ed.
 p. cm.
 Includes index.
 ISBN 978-1-60061-075-2 (pbk. : alk. paper)
 1. Handicraft. 2. Mixed media painting. 3. Wearable art. I.
Title.
 TT157.B832 2008
 745.5--dc22
 2007052004

Editors: Tonia Davenport
and Robin M. Hampton

Cover Design: Maya Drozdz

Interior Design: Marc Whitaker,
MTWdesign.net

Production Coordinator:
Greg Nock

Photographers: Christine Polomsky
and Al Parrish

Photo Stylist: Jan Nickum

fw
F+W PUBLICATIONS, INC.
www.fwpublications.com

Dedication

This book is dedicated to my husband, Andy, who allows me the space to create and the freedom to spill paint on anything and everything, supports my dreams, puts up with my excessive planning, always encourages rule breaking and is a devoted friend who loves me through it all—my gratitude.

Acknowledgments

Thank you to my mom and dad for fostering my creative growth and being shining examples of faith. Thank you to my brother for being one of the smartest people I know and for sharing his smarts with me through this process. Thank you to all the special friends who believe in my abilities. Special thanks to my friend and talented photographer, Duvy.

Thank you to the North Light team—especially Tonia, Robin, Maya, Marc and Christine—who are some of the kindest hardworking people with the best taste in cuisine whom I have yet to meet!

CONTENTS

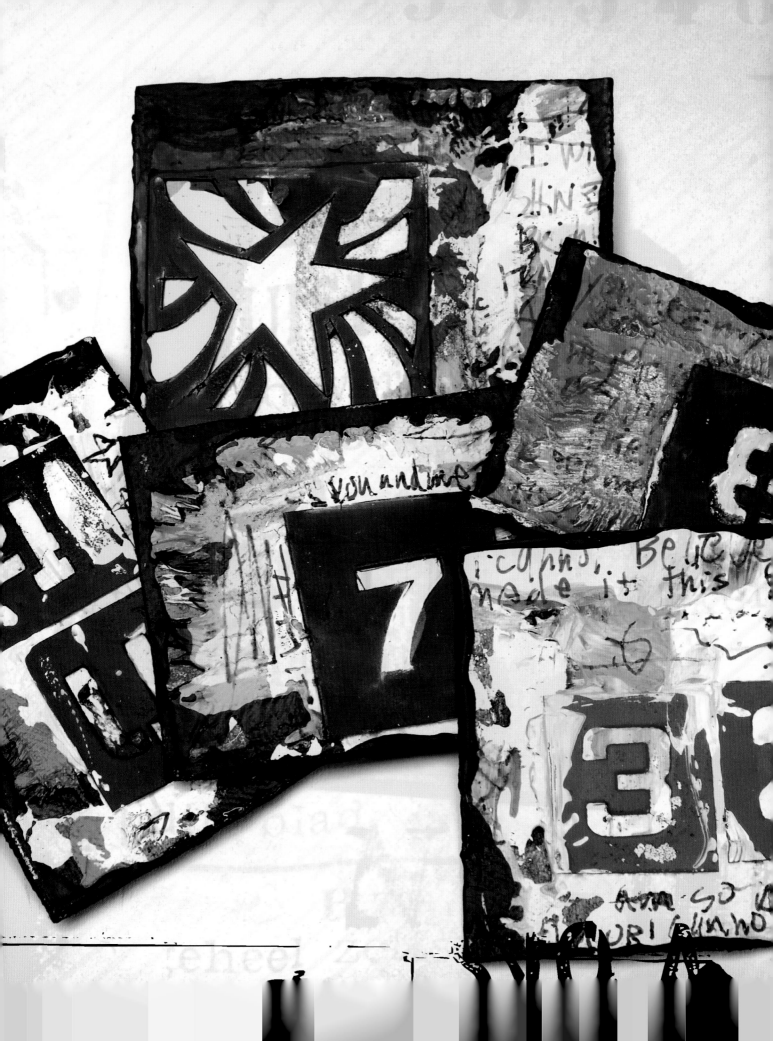

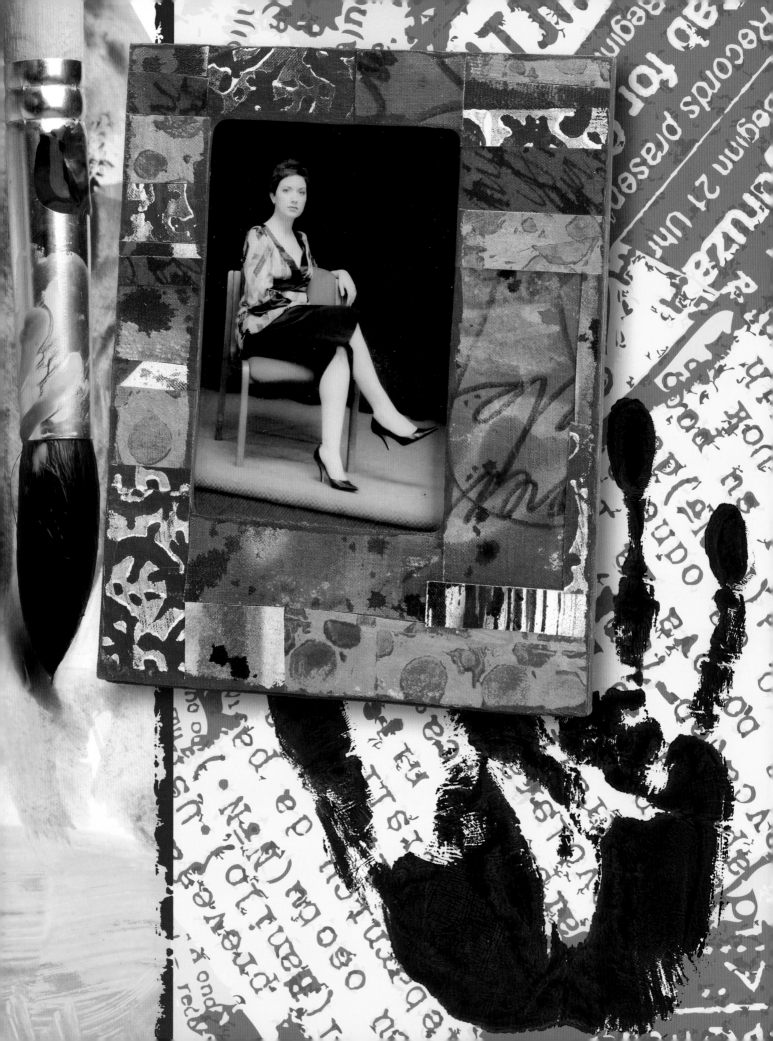

Introduction
PUSH YOUR BOUNDARIES

I still remember the first time I globbed paint onto a canvas, smeared color all over my pants, stretched a canvas and got butterflies in my stomach before a class critique my freshman year in college. There was something special about paint that I was drawn to—or maybe I just loved making a mess. The learning process was exciting, fresh and consuming. So it didn't take long for me to become passionate about everything regarding the medium. I decided to major in painting, took as many classes as possible and slowly began developing my own style, which was messy, narrative and always personal.

I started my paintings with freewriting, dripping paint and using vibrant colors and then painted the assignments on top of the multiple layers. Even then I was crazy about paint, text and images piled on top of one another. I loved being an art major but was frustrated by the confines of the assignments. I always looked for ways to break the rules and loved rebelling against the traditional standards of painting. With study and experimentation, I found my voice as a painter and became comfortable challenging the concept of art.

After college, my journey as a painter brought me to a place where a canvas with four sides was just not enough. I wanted to break free from working within a square. I continued painting compositions, but I began to paint more on unstretched canvas. Then I started ripping and cutting these paintings and turning them into something new. The first time my husband saw me rip a painting, he looked at me like I was crazy. I began using my paintings as fabric. I taught myself to sew and started making a new

kind of art. My breakthrough happened when I needed a one-of-a-kind purse to accompany a little black dress. I was suddenly inspired to rip a painting right off the stretcher bars and cut it up to sew into a clutch handbag. The result was a unique piece of art and was the beginning of truly pushing my boundaries.

My evolution as an artist and a painter has been a fulfilling process, and it's hard to believe that fourteen years have passed since that first painting class. I now have years of experience showing and selling art, redefining my style and breaking all sorts of creative rules. Through it all my favorite materials are still canvas and paint. But the best part of being a painter is sharing my art and process with others. Teaching my techniques is gratifying, and encouraging others to break the rules is downright exciting!

My intention for this book is to introduce you to my world and bring inspiration to your own artwork and mixed-media creations. *Canvas Remix* is all about pushing the envelope with traditional materials and redefining the concept of what painting can and should be. From graffiti to whimsical images to art history to punk-rock culture to vintage elements, I've sprinkled the pages of this book with the many things that have influenced me and defined who I am as a painter. I'll introduce you to tricks and tools painters use, techniques that range from freewriting to splattering to making a wonderful mess. You'll then push your canvas paintings and transform them into something completely new. Be prepared to cut, rip, sew and remix your canvas into unconventional accessories and imaginative mementos. Welcome to *Canvas Remix*!

SUPPLIES AND TOOLS

Everyone can learn to use the same simple materials that painters use. You don't have to be an art major or even consider yourself an artist to appreciate paint and canvas. Learning to use paint is about getting to know your supplies and finding what works best for you. Don't spend a lot of money on expensive materials. Instead, splurge on one or two items and get creative with the rest. Think outside the box when it comes to your tools and supplies—all sorts of household items can be used to apply paint. Home-design centers also offer great options for paint and tools that are often quite affordable. Enjoy the process of painting and try not to get caught up in needing the perfect supplies. Creating with paint and canvas should be fun and experimental!

Paint

There are numerous choices when working with paint. From oils to acrylics to watercolors, the options and brands are vast. The projects in *Canvas Remix* primarily call for acrylic paint because it's versatile, quick to dry, easy to clean up and inexpensive. It's used with water as a thinning agent and can also be mixed with different mediums and additives to achieve better glazes and create vibrant colors. Basic acrylic craft paint works great, but experiment with different brands and qualities to find what best suits you.

Spray Paint

Spray paint comes in aerosol cans and is available in many colors and finishes. Because it's a portable and permanent medium, it's commonly associated with graffiti or street art, but that doesn't mean you can't use it in your projects. There are many brands of spray paint that range in price and colors and come with different tips to control the width and density of the spray. It's a great accent tool. Always have a can of cheap black spray paint on hand and splurge on exotic colors when needed. (Just remember to always use spray paint in a well-ventilated area.)

Paint Applicators

Brushes are the traditional tools for applying paint and come in many shapes, styles and price ranges. If you treat your brushes poorly, as I do, buy inexpensive ones from hardware stores and splurge on small brushes for detailed painting. Choose brushes based on the project. For larger surfaces, try house-painting brushes to cover more surface area.

You can also try using nontraditional tools to apply paint, including sponges, rags, combs, condiment bottles, paint rollers and even your hands.

Writing Devices

Writing and marking play big roles in my own expression. Simple permanent markers will go a long way when it comes to writing and drawing. They are perfect to use on top of or under paint, to sketch your composition or to put finishing details on a drawing. Have a variety of sizes, shapes and colors of permanent markers on hand when creating.

If you can make a mark with it, try using it in your art. There are so many great options these days for writing and

drawing utensils, from paint pens to charcoal to white-ink pens. Find what is most enjoyable for you.

Stamps

Rubber, foam and acrylic stamps are widely available at craft stores, and you can also carve your own unique stamps using carving blocks, wood blocks and craft foam (see pages 30–31). Stamps can be used to easily create a textured background and add visual interest.

Images

Create aesthetic appeal and add a narrative quality to your art by incorporating images in your paintings. If drawing images freehand doesn't come naturally, you can still add a personal touch by incorporating images in other ways: Use photocopies of old family photos, duplicate photos developed specifically for a painting, tear out interesting pages from newspapers, magazines or old books. Experiment with image-transfer techniques, too (see pages 32–33).

Printing a photo directly onto canvas is another way to use images and computer-generated text in your work and can be done in a variety of ways. The following options create a surface that's stable enough to go through a printer: Purchase canvas cloths that are pretreated for printers, which are available at a variety of office- or art-supply stores; adhere the shiny side of freezer paper to your raw canvas with an iron; or adhere canvas to cardstock by taping the edges to the paper.

Mixed-Media Ephemera

Many contemporary painters use ephemera to create narrative and meaningful paintings. Take your painting to another level with text, images and photography. Recycle anything you can attach to canvas, including stamps, postcards, receipts and colorful food packaging. The ideas are endless, and there's always a way to incorporate ephemera.

Stencils

Use stencils and spray paint to take your compositions to an urban level, inspired by street graffiti. Whether you're using intricate designs or simple letters, stencils are an easy way to add patterns and images to artwork. All you need is cardstock, a craft knife and a little imagination to cut shapes and designs that best fit your art.

Canvas

Canvas is typically made from cotton and comes in both plain and duck. Duck canvas is comprised of tightly woven threads and can be purchased in a variety of weights based on the purpose. You can purchase stretched canvas, canvas board or canvas by the yard. Raw and unstretched canvas is cheaper and allows you more freedom with your paintings after they are finished. Most art-supply stores sell yardages of canvas. Fabric stores are also an option and are sometimes more affordable. Canvas is one of the most versatile surfaces on which to create because it's sturdy and allows for thick layers. It can be stretched, cut, sewn, ripped and repurposed. Plus, it lasts a long time. Most of the projects in *Canvas Remix* call for unstretched canvas.

Stretcher Bars

Use stretcher bars to construct a wooden frame to use for stretching and mounting canvas. Premade stretchers come in segments with interlocking corners that can be put together like puzzle pieces.

Palette and Palette Knife

Use a palette to mix your paint colors. Available in all shapes, sizes and materials—usually wood, glass or plastic—palettes are often held by painters as they work. If you don't want to invest in an expensive palette, use Styrofoam plates or wax paper, or cover a plate with plastic wrap. Art supply stores even sell pads of disposable palette paper.

Painters traditionally use a palette knife to mix paint on a palette, but many painters also use it to apply paint directly to the canvas—a great way to create thick layers and texture in a painting.

Sewing Machine

Sewing painted canvas adds a new dimension to your paintings. Not only can you attach ephemera to the surface, but you can create lines and texture with the machine and sew your painting into something new. Many of the projects utilize machine sewing because it's more convenient, but you can hand-sew as an alternative.

Heavy-Duty Needle

Thick and strong (sizes 70/10–110/18) needles with very sharp points are ideal for stitching through multiple layers without breaking. Use them for stitching denim, canvas and other heavy, tightly woven fabrics.

Gel Medium

Use gel medium as a binder when attaching ephemera to canvas. You can also use it for image transfers (see page 32), or mix it with acrylic paint to extend the color and create glazes and even glossy finishes.

All-Purpose Craft Glue

Glue can do wonders when used with canvas. Gluing layers of canvas together creates a denser surface, that's much stronger and can be used in all sorts of innovative ways. Glue is also one of the best binding agents for attaching objects to canvas.

Polyurethane Sealer

Seal your canvas paintings with a polyurethane finish. Use a water-based polycrylic in a gloss finish. It adds a nice sheen to the surface and, more important, a protective layer to the canvas. Find polyurethane in art and craft supply stores, home-improvement stores and even lumber yards.

TECHNIQUES

When I first started painting, I loved learning new techniques and different ways to achieve a variety of textures, looks and emotions with materials. My most profound discoveries came from experimenting and taking time to understand the nature of the medium. My happiest moments still occur when I'm alone with my thoughts, tubes of paint are scattered everywhere and my hands, messy with paint, are trying to mix a color or find the best way to create a pattern. Not only is paint the perfect vehicle for expression, but it's fluid and forgiving by nature. Mistakes can be painted over, color can be altered and supplies can be recycled. This makes experimentation fun. You don't need official training or drawing and painting skills to learn the same methods that professional artists use. Anyone can incorporate paint into her projects.

In this chapter, you'll explore my favorite painting techniques that serve as the foundation of my artwork. Many of these techniques are pulled from portrait painters, mixed-media artists, abstract painters, graffiti artists and even house painters. You'll also explore innovative ways to transform and remix your canvas, such as ripping, gluing and sewing. All of these techniques are intended as inspiration and the first step in finding your own process and discovering your voice with paint.

Stretching Canvas

Learning to stretch your own canvas is a fundamental technique, and it can save you a lot of money. Check your local art-supply for canvas by the yard and stretcher bars. All you need is a staple gun to put it all together.

Materials
unprimed canvas
stretcher bar
staple gun
scissors

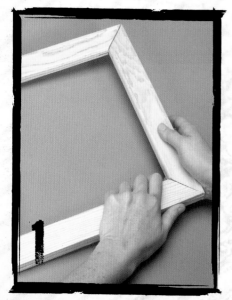

Assemble the frame
Connect the stretcher bars according to the manufacturer's instructions.

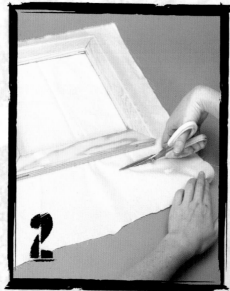

Trim canvas
Trim the canvas to leave about 1" (3cm) of space around the frame.

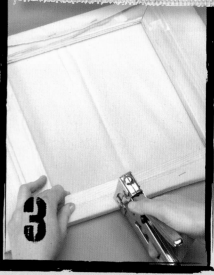

Staple canvas
Staple the top of the canvas to the top bar first using 2 staples that are just right and left of the center. Repeat for the bottom bar.

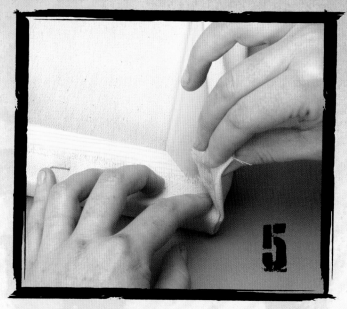

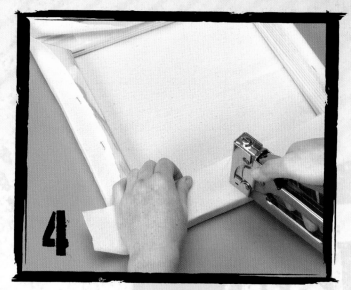

Staple remaining sides
Pulling the canvas taut, repeat step 3 for the 2 sides. Be sure to staple 1 side first and then the other. Smooth canvas and apply more staples as needed.

Fold corners
When you get to the corner, fold it in as though you're wrapping a present. Staple the canvas in place.

Priming Canvas

Because canvas is porous, you may want to prime your canvas to keep paint colors vibrant and prevent pen and markers from bleeding. (Painting on unprimed canvas creates a more muted effect—whether or not you prime your canvas is up to you.) Here I'll show you how to use gesso to prime your canvas, but you can also use a basecoat of paint as a primer.

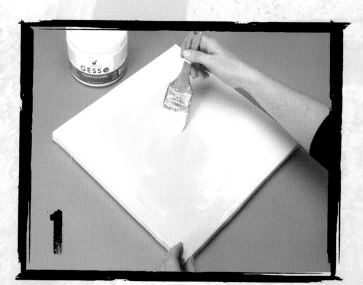

Materials

unprimed stretched canvas
gesso
paintbrush

Apply gesso to top
Using a paintbrush, cover the top of the canvas with gesso.

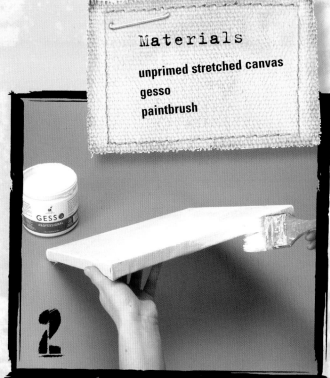

In the Mix
When I was a student on a strict budget, I found that a can of white house paint would go a long way in my art. I have loved using it ever since! Although it can't be mixed or blended in the same way as traditional artist paint, it's inexpensive and acceptable to use for priming.

Apply gesso to sides
Using a paintbrush, cover the sides of the canvas with gesso. Keep in mind that the texture you leave with the brush and gesso will show through when you paint it.

Ripping Canvas

Cutting your canvas is an easy and crisp way to size it, but I like to rip my canvas for a raw look. The best part about ripping is that you can pull the edges of the canvas to create an intentional frayed edge.

Materials
canvas
scissors

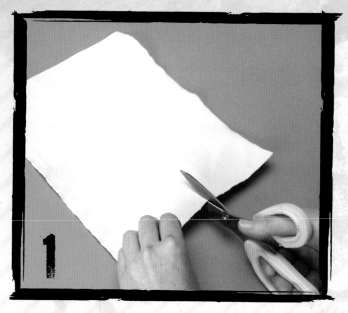

Cut canvas
Begin by making a small cut where you want a rip.

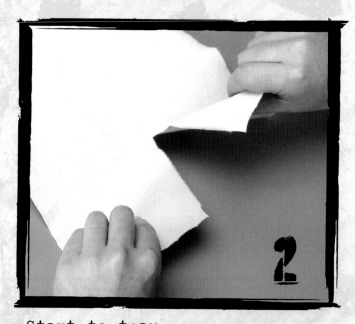

Start to tear
Firmly grasp half of the canvas in each hand and tear it apart.

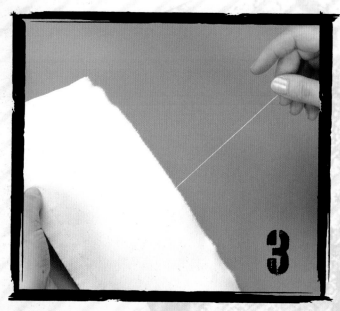

Remove loose ends
After the canvas has been ripped, fray the edges a bit by removing any loose strands.

In the Mix
Stiff, dried brushes create a textural stroke.

Applying Heavy Brushstrokes

I love the look of heavy brushstrokes and often incorporate them throughout my work for a bold appearance, a splash of color and even balance. Pick colors that contrast with your background to make your brushstrokes stand out.

Materials

painted canvas

palette

1 color of paint in a contrasting color to the painted canvas

wide, stiff brush

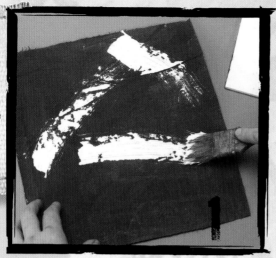

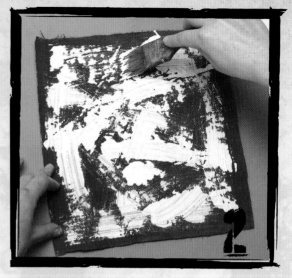

Apply paint
Squeeze paint onto your palette. Pick up some color on your brush and drag it across the canvas.

Continue painting
Repeat the motion in several directions, picking up more paint as needed, until the canvas is as full as you'd like it.

Blending Color

Blending color is a simple painting technique that can drastically change the look of your composition. Use blending over and over in your work to create variations of a color and to add layers and texture. Blend colors on your palette or even directly on your canvas.

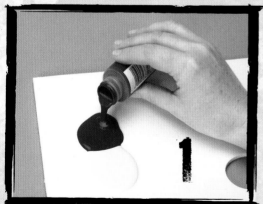

Materials

canvas

paint (2 or more colors)

assorted brushes

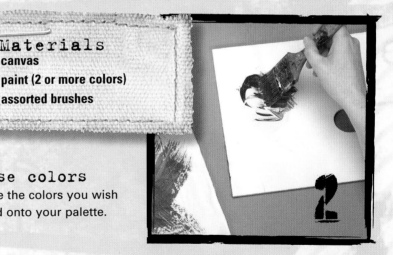

Choose colors
Squeeze the colors you wish to blend onto your palette.

Apply paint to brush
Drag the brush through the paint, picking up some of both colors.

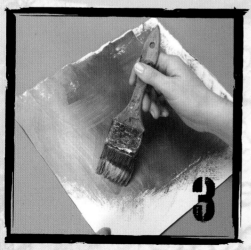

Apply color to canvas
Brush the color onto the canvas, mixing it slightly as you brush. Brush in several directions. Add highlights with any color, if desired.

Splattering

Inspired by the abstract expressionist paint-ers, one of my favorite techniques is splattering paint. Incorporate this technique into paintings to attain a background full of texture and a messy appearance.

In the Mix
If you don't want to make a mess with splat-tering, take your project to the bathroom and splatter within the confines of the tub. When you're finished, cleanup is as easy as turning on the water!

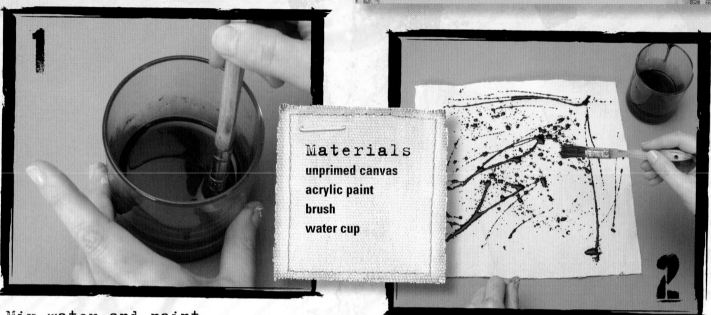

Materials
unprimed canvas
acrylic paint
brush
water cup

Mix water and paint
Mix water with the paint until it has a runny consistency.

Flick paint
Using a flicking motion, apply the runny paint to the canvas. Drizzle paint with the brush and let it drip.

Scribbling/Drizzling

Create a messy texture by drizzling paint onto your surface and scribbling into it. The best way to do this is to use a bottle with a small tip (such as an old condiment bottle).

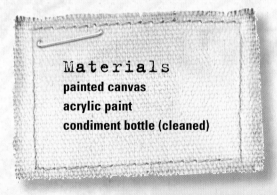

Materials
painted canvas
acrylic paint
condiment bottle (cleaned)

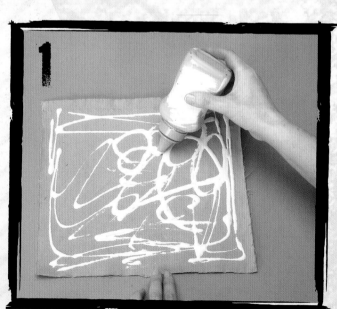

Mix and apply paint
Mix some paint with a bit of water and pour it into the condiment bottle. Use the bottle to scribble over the painted canvas.

In the Mix
Get creative with your drizzling techniques! Use chopsticks dipped in paint, or poke a hole in a paper cup and let the paint drizzle over your canvas. The possibilities are endless.

Color Washing

I enjoy merging techniques from different mediums, and I've found that you can use acrylic paint very much like watercolors. Water down your paint to create an illusion of transparency. This technique of wetting the background and then applying color is something that watercolor artists use to achieve a painterly effect.

Materials
unprimed canvas
acrylic paint
brush
water cup

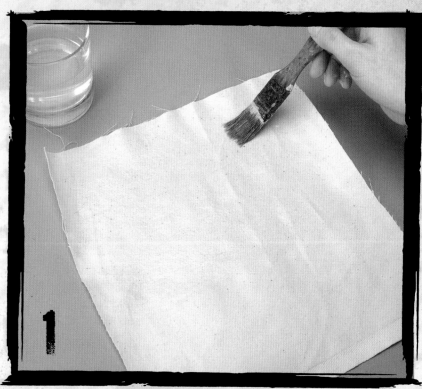

Wet canvas
Using a brush, cover the piece of canvas with water.

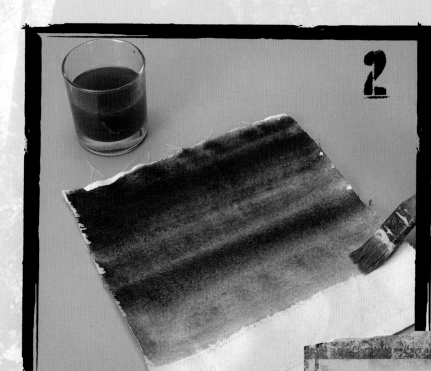

Add paint
Mix a small amount of paint with the water, then brush the color over the wet canvas.

In the Mix
Combine different colors and let them blend into each other.

Texturing with a Palette Knife

Forget about confining your palette knife to mixing color on your palette. Use this tool to apply thick paint to canvas. Painting with your knife is like icing a cake—and an excellent way to create texture and thick ridges.

Materials

primed canvas

palette

acrylic paint (2 or 3 colors)

palette knife

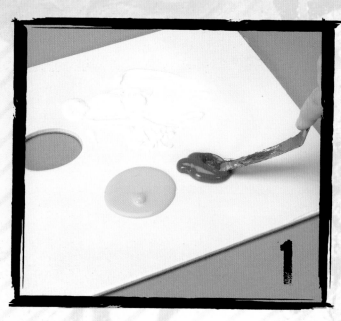

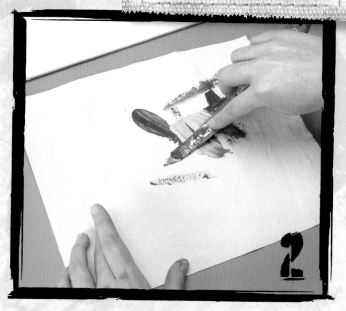

Pick up paint
With the palette knife, pick up the first color of paint.

Apply paint
Spread the paint in strokes onto the canvas.

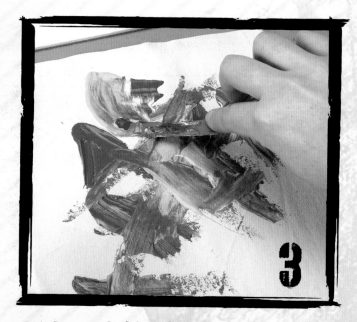

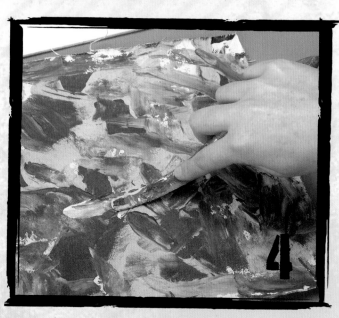

Apply and blend colors
Pick up different colors and apply them to the canvas with additional strokes, blending the colors a bit as you apply them.

Finish
Continue until the piece is covered in strokes.

In the Mix
Experiment with a variety of sizes and shapes—putty knives, small spatulas and even small trowels can be used like a painter's palette knife.

Sponging

Paired together, a sponge and paint can create depth, texture and pattern. My favorite way to use sponges is combining light and dark colors for contrast and interest.

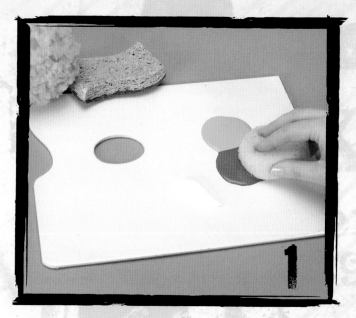

Pick up paint
Squeeze 3 colors onto your palette. Pick up the first color of paint with a dry sponge.

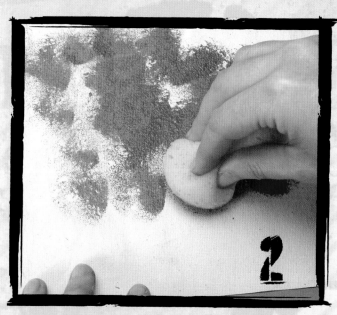

Apply paint
Begin dabbing color onto the canvas.

Materials
primed canvas
acrylic paint (3 colors)
3 different sponges

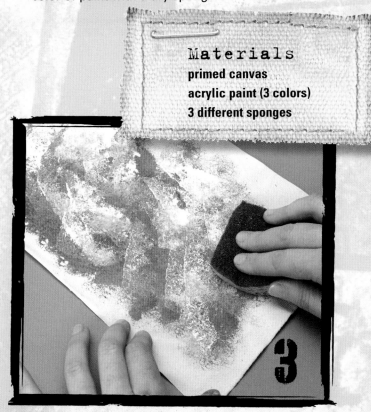

Apply second color
Select a second sponge and randomly apply a second color over the first.

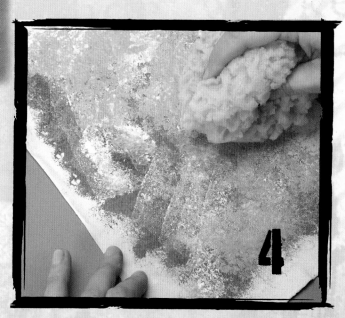

Finish
Repeat Step 3 with the third color and sponge.

Crackling

Use the crackle effect to create a distressed appearance. There are numerous ways to achieve crackle with your paint, but I have the best luck with crackle medium. I often use crackle over the top of a paint layer to give the appearance of time and aging.

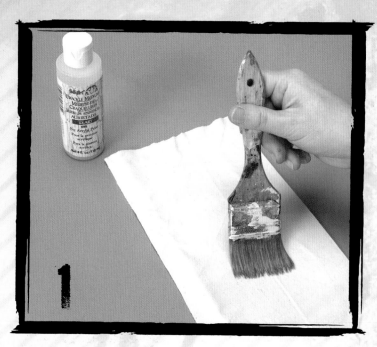

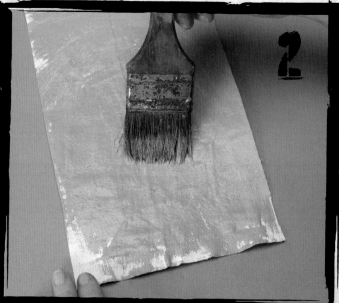

Materials
primed canvas

acrylic paint

crackle medium

water cup

paintbrush

hair dryer (optional)

Apply crackle
Apply a solid basecoat of the crackle medium to the primed canvas. Let it dry.

Apply paint
Thin paint with water. Apply a solid coat of thinned paint over the dried crackle medium.

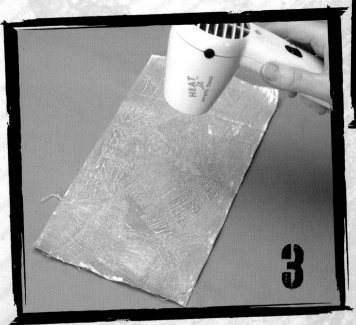

Blow-dry (optional)
As the paint dries, crackles will appear. If desired, you can use a hair dryer to speed up the process.

Glazing

Use glazing techniques to achieve subtle color or to create depth through light layers of paint. Apply thin, translucent layers of color on top of each other to achieve a richness you can't attain by merely mixing paints on your palette.

Materials

primed canvas
palette
acrylic paint (2 colors)
fluid medium

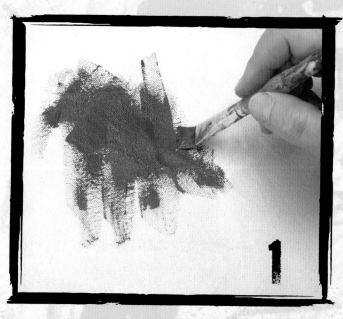

Apply first color

Squeeze 2 colors of paint and some fluid medium onto your palette. Randomly apply the first color to the canvas.

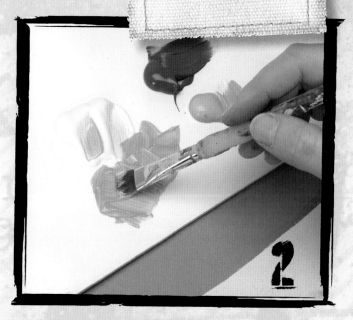

Mix second color

Pick up the second color with your brush and mix it on the palette with some fluid medium.

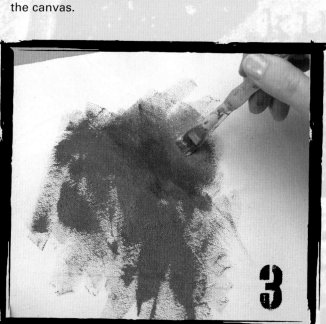

Apply second color

Brush the second color onto the canvas, overlapping the first color in some areas.

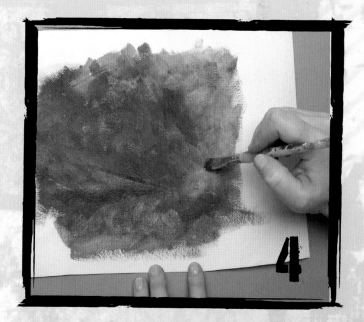

Alternate colors to finish

Continue alternating between using each color alone and in combination with the medium to cover the entire canvas.

Scrunching

Scrunching was a happy mistake that occurred when I was mixing colors on my raw canvas and became frustrated with my results. I crumbled up my canvas and realized I had just created something unique! The result was an unconventional way to mix color without using a brush. I use scrunching when I want to cover my canvas but save myself time.

Materials
unprimed canvas
acrylic paint (3 colors)

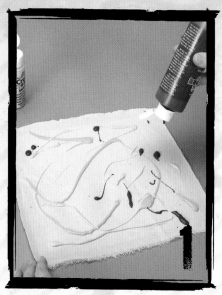

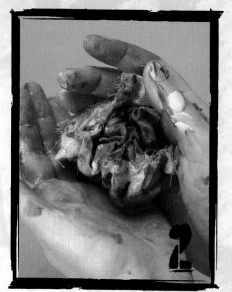

Apply colors
Squeeze a bit of each of the 3 colors onto the canvas.

Scrunch canvas
Pick up the canvas and crumple it with your hands, working the color into the canvas.

Unfold
Unfold the canvas and ta-da!

Ragging

Applying paint to your canvas with a rag achieves a soft and textured effect. Drag your rag across the canvas, dab it in circles or use whatever method feels right to you.

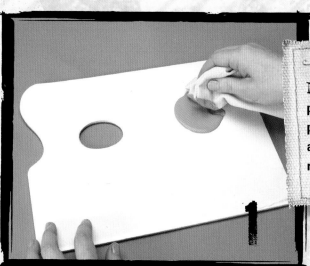

Materials
primed canvas
palette
acrylic paint
rag or scrap of canvas

Apply paint
Drag the rag over the primed canvas to apply long strokes of color.

Pick up paint
Scrunch up a rag or bit of canvas and pick up some color from your palette.

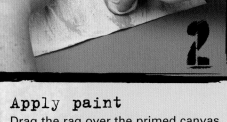

In the Mix
The look you create with the ragging technique depends on the material of the rag.

Masking with Tape

Use masking tape to create crisp lines, block off sections of color and save areas from dripped paint.

Materials
primed canvas
acrylic paint (3 colors)
brush
masking tape

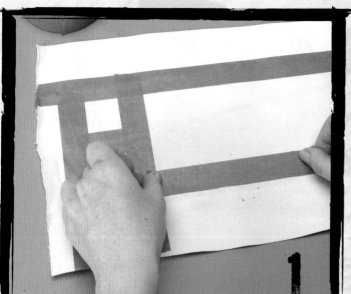

Apply tape
Apply lines of tape to the primed canvas, creating whatever design you like.

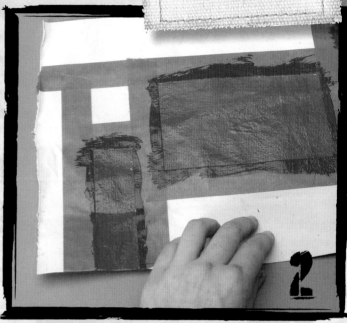

Apply first color of paint
Brush the first color onto the areas of your choice.

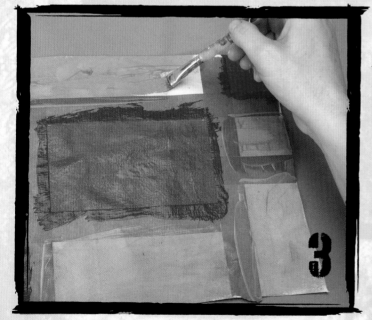

Apply remaining colors
Continue painting the shapes made with the tape until the canvas is full.

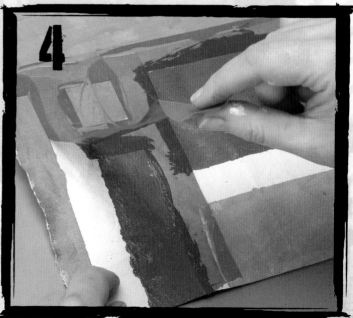

Remove tape
Let the paint dry and carefully remove the tape.

Painting Simple Shapes

Repeating simple shapes is a wonderful way to create visual interest. When I want to fill my canvas with color and lines, I draw inspiration from abstract artists and use painted shapes to cover my surface.

Materials
primed canvas
acrylic paint (3 colors)
2 paintbrushes (1 flat and 1 fine)

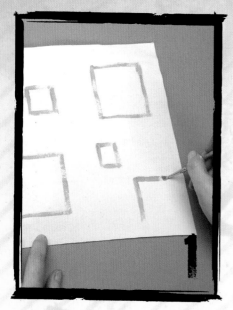

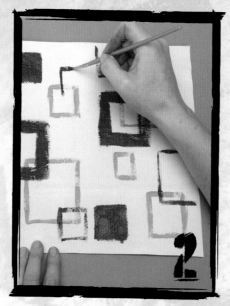

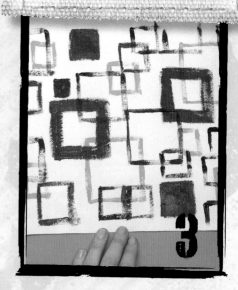

Paint first shapes
With the first color, begin painting randomly placed squares, using the finer brush.

Create more shapes
With a second color and the wider brush, add squares around the canvas. Paint over some of the squares from Step 1, and make some squares solid.

Apply final color
Repeat for the third color, using the finer brush.

Combing

Using everyday items to apply paint is an easy method to produce new and different appearances. Running a comb through wet paint is a fun way to create pattern and texture.

Materials
primed canvas
palette
acrylic paint
comb

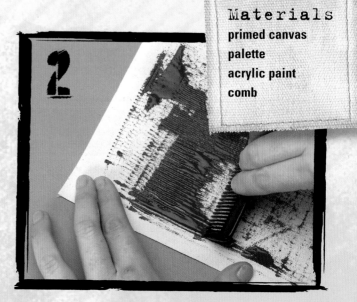

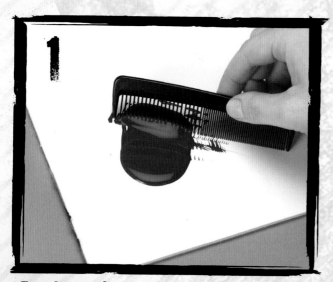

Drag comb on canvas
Use the loaded comb to create texture on the canvas, using vertical and horizontal strokes. Don't worry if the paint is heavier in some areas than others.

Load comb
Squeeze some paint onto your palette and pick some of it up with a comb.

In the Mix
Running your comb across dry paint is another way to distress a surface and create a more rustic look.

Roller Painting

Don't limit your paint rollers to house painting. Use rollers in a variety of sizes for a quick way to paint your surface. Create all kinds of funky shapes and textures with a roller. Quickly rolling the roller on the canvas doesn't provide as much coverage, and allows the underneath layers to show.

Materials
primed canvas
palette
acrylic paint
paint roller

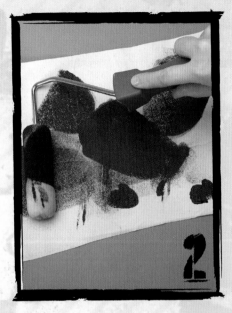

Apply paint to roller
Squeeze some paint onto your palette and load the roller with paint.

Roll paint on canvas
Roll the paint onto the canvas, going in multiple directions.

Repeat
Reload the roller as needed and continue until the canvas is covered as desired.

Materials
painted canvas
sandpaper
wood block

Sanding

There are many ways to use sandpaper to alter your painted canvas. I like to sand away a layer to reveal the layer below. It's great for creating a distressed look and adding texture and lines on the surface.

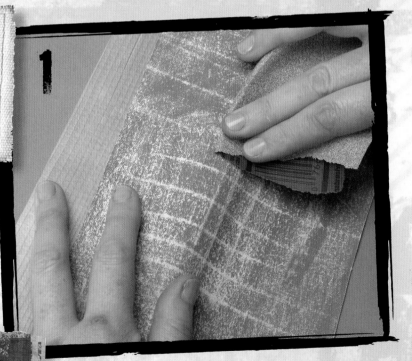

Sand canvas
Place a painted canvas on the edge of a wood block. Rub the sandpaper on the canvas.

In the Mix
Try different grits of sandpaper for different effects. The lower the grit number, the rougher the sandpaper.

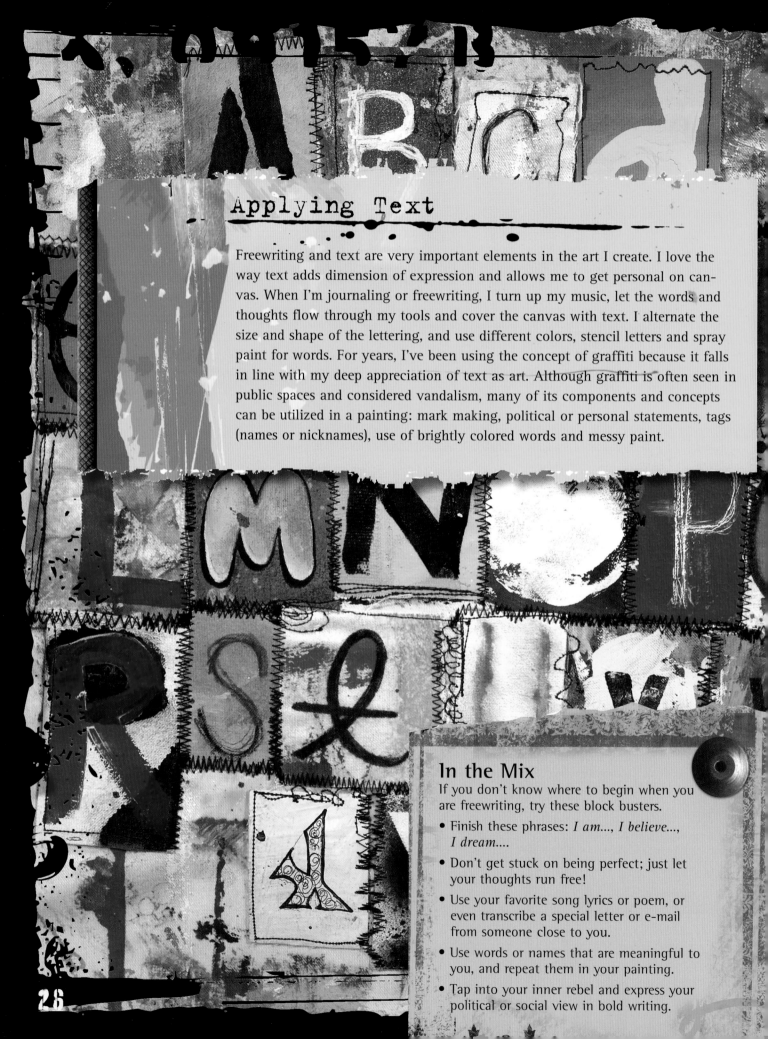

Applying Text

Freewriting and text are very important elements in the art I create. I love the way text adds dimension of expression and allows me to get personal on canvas. When I'm journaling or freewriting, I turn up my music, let the words and thoughts flow through my tools and cover the canvas with text. I alternate the size and shape of the lettering, and use different colors, stencil letters and spray paint for words. For years, I've been using the concept of graffiti because it falls in line with my deep appreciation of text as art. Although graffiti is often seen in public spaces and considered vandalism, many of its components and concepts can be utilized in a painting: mark making, political or personal statements, tags (names or nicknames), use of brightly colored words and messy paint.

In the Mix

If you don't know where to begin when you are freewriting, try these block busters.

- Finish these phrases: *I am...*, *I believe...*, *I dream....*

- Don't get stuck on being perfect; just let your thoughts run free!

- Use your favorite song lyrics or poem, or even transcribe a special letter or e-mail from someone close to you.

- Use words or names that are meaningful to you, and repeat them in your painting.

- Tap into your inner rebel and express your political or social view in bold writing.

Applying Text with Watery Paint

Apply paint

Create a watered-down paint by adding water to acrylic paint. Dip the brush in the paint mixture and write quickly with it on the canvas, as if you were using a pen. Reload the brush frequently and use a very light hand.

Materials
- unprimed canvas
- acrylic paint
- liner or similar brush
- water cup

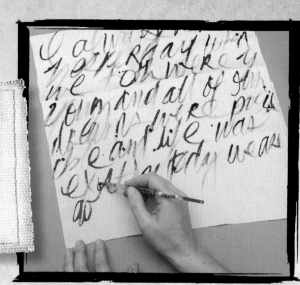

Spray-Painting Text

Apply paint

In a smooth and steady motion, use spray paint to paint your letters. Lay your canvas on a board or large piece of paper so you can easily paint off the edges.

Materials
- painted canvas
- spray paint

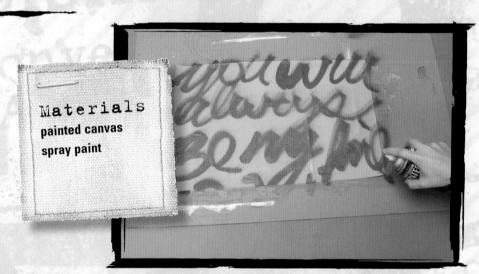

Applying Text with Marker and Wash

Materials
- unprimed canvas
- permanent marker
- acrylic paint
- wide brush
- water cup

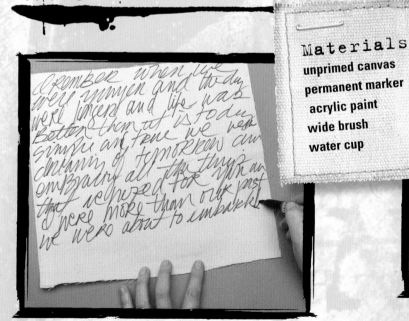

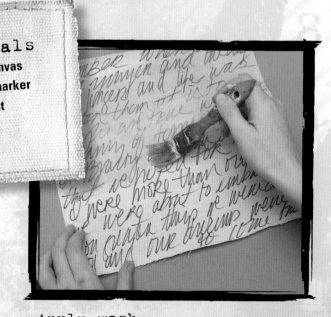

Write with marker

Use a permanent marker to fill the canvas with journaling.

Apply wash

Use a watered-down paint to wash over the text with a wide brush.

27

Applying Text of Varying Sizes

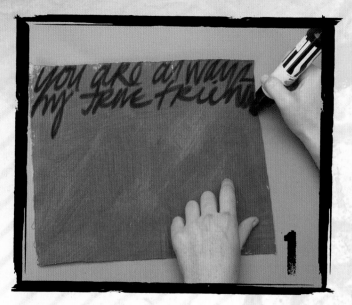

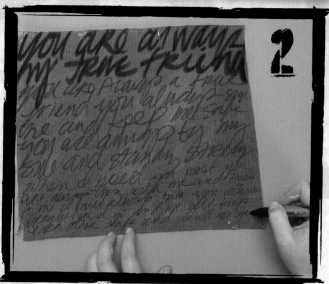

Write with large marker
Begin writing with the largest marker.

Continue with smaller markers
Continue writing with the next-largest marker. Finish writing with the smallest marker.

Applying Text with Shoe Polish

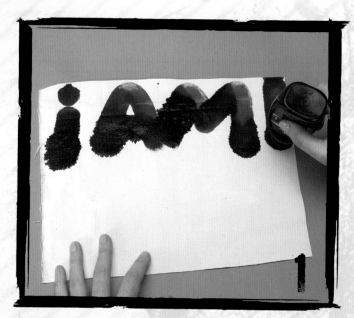

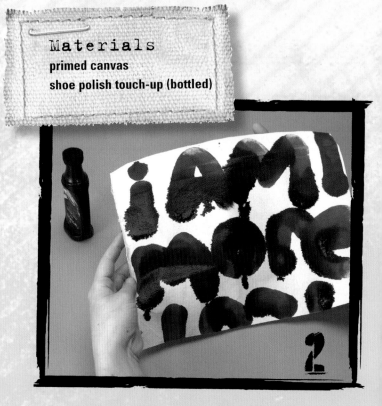

Write with shoe polish
Using the shoe polish as a marker, write your text.

Tilt canvas (optional)
When you use a generous amount of shoe polish, you can hold the canvas up to allow the polish to drip and create a messy look.

Using Photos as Stencils

I've always been inspired by punk bands that use stencils in place of flyers or posters to promote themselves in public spaces through the use of images and designs. You can apply this same principle to your art by using a photo as a template.

Materials
primed canvas
spray paint
photo paper or cardstock
cutting mat
craft knife
computer with photo-editing software
printer

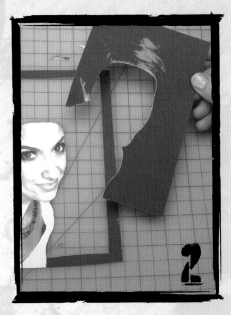
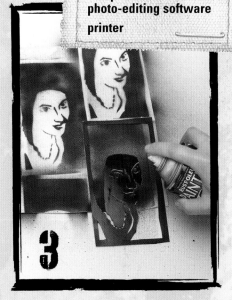

Print photo
Using photo-editing software, convert a photo to high-contrast and print it on photo paper or cardstock.

Cut out black
Using a craft knife and a cutting mat, begin cutting away areas that are black, being mindful to leave the stencil intact. Leave a border around the photo to hold everything together and to act as a frame.

Apply final color
Position the stencil over the canvas and apply the spray paint.

Painting Stencils

You don't have to use spray paint with a stencil—you can use a stencil brush with your designs. Try to cover the entire surface of your canvas to create an interesting pattern or texture.

Materials
primed canvas
palette
acrylic paint
stencil brush
stencil

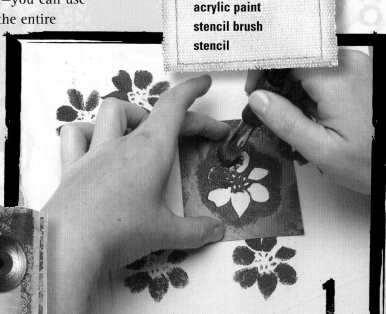

Apply paint
Squeeze some paint onto your palette and load it onto a stencil brush. Place the stencil on your canvas. Bounce the stencil brush over the stencil and onto the canvas. Repeat as desired.

In the Mix
Portraits of people can create edgy stencils. Use photos with strong lines and high contrast. When taking pictures, look for interesting images that you can later convert to stencils for use in your art.

Carving and Printing Soft-Block Stamps

Carving your own stamps is a fun way to create distinctive patterns and designs to use in your artwork. And forget about limiting your stamping to ink pads—try using paint! Soft blocks are traditionally used as practice material by novice print makers. This rubber-like material is soft enough to carve and great for creating stamps.

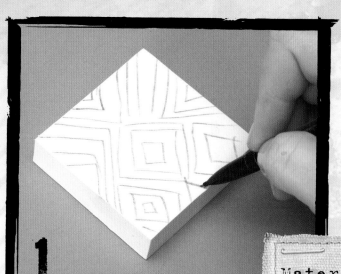

Materials

painted canvas

acrylic paint

brush

piece of soft block

pencil

carving tools

Design stamp

Using a pencil, create your design on a soft block.

Carve design

Use carving tools to carve away the material on the drawn lines.

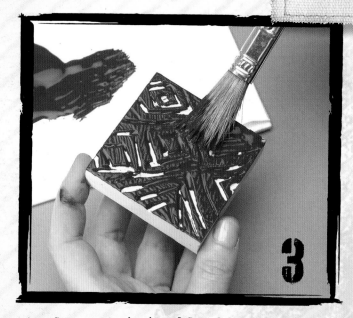

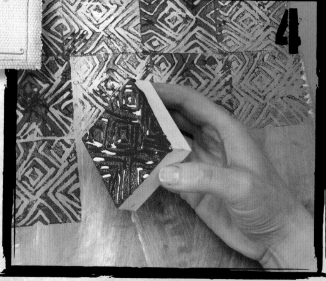

Apply paint to block

Ink the completed block by applying paint to the carved side with a brush.

Stamp image

Repeatedly stamp onto the canvas to create a background.

In the Mix

Erasers, wood blocks, linoleum blocks, soap and even potatoes can be carved into stamps.

Carving and Printing Foam Stamps

Use craft foam for an easy way to create fun stamps. A wood-burning tool can carve lines and texture into the surface quickly.

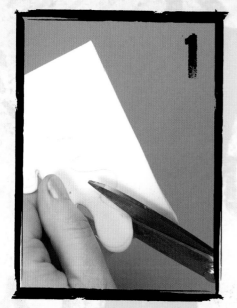

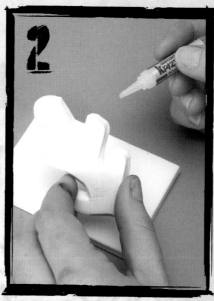

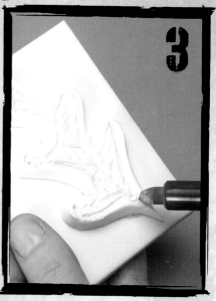

Carve details

With a wood-burning tool, carve details into the shape.

Draw and cut shape

Draw a shape on a piece of craft foam and cut it out with scissors.

Attach shape to foam block

Adhere the shape to a square of craft foam using all-purpose glue.

Materials

primed or painted canvas

acrylic paint

brush

piece of thick craft foam

scissors

all-purpose glue

wood-burning tool

pencil

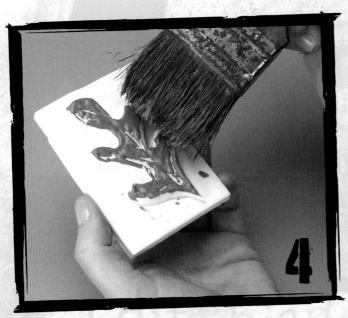

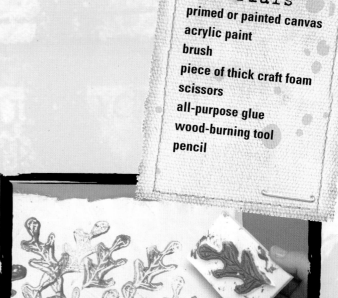

Apply paint

Use a brush to apply paint to the stamp.

Stamp image

Stamp the canvas repeatedly to create a background, re-inking as needed.

Transferring Images

The ability to incoporte artful images into a painting doesn't need to be limited to those with drawing skills. Image-transfer techniques are a great way to add an image while letting the background show through.

Apply medium
Brush matte medium onto the ink-jet image.

Apply photo to canvas
With the image side down, apply the photo to the canvas. Here, I have left a gessoed area on the canvas for it.

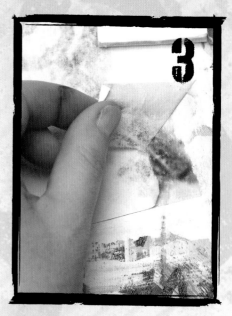

Remove paper
Let it dry. Then gently peel away the paper.

Materials
painted canvas
water cup
matte medium
brush
ink-jet image
acrylic paint (optional)

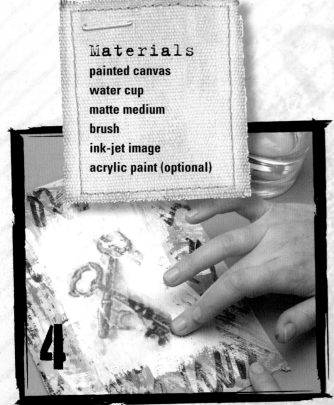

Use water to remove residue
Use water and your fingers to gently rub off any remaining paper.

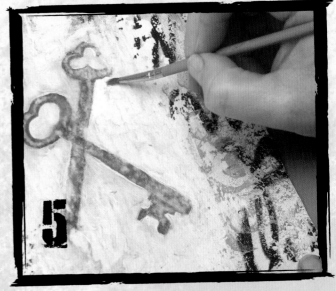

Add details (optional)
Add details with paint and a brush.

In the Mix
Look for images that will complement your background layers. Don't forget that some images and text may need to be reversed using photo-editing software before printing and transferring them!

Using Iron-On Transfers

Another simple way to add images to your work is to use iron-on transfers. Hot iron-on transfers adhere smoothly to your painted canvas and will withstand the test of time. You can even paint over them.

Materials
- **painted canvas**
- **acrylic paint**
- **brush**
- **ink-jet-compatible iron-on sheet**
- **iron and ironing board**
- **ink-jet printer**

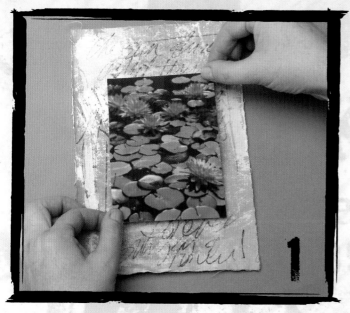

Print image
Print your image onto the iron-on sheet, according to the manufacturer's instructions. Decide where you want the image to go on your canvas, and place the sheet, image side down, where you want it.

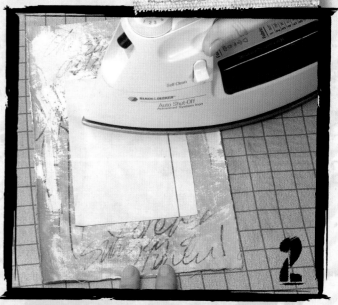

Iron image
Transfer your canvas to an ironing board and go over the iron-on sheet with the iron, following the manufacturer's instructions.

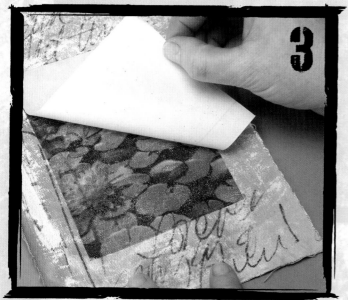

Remove backing
When it has cooled, gently peel away the backing to reveal the transfer.

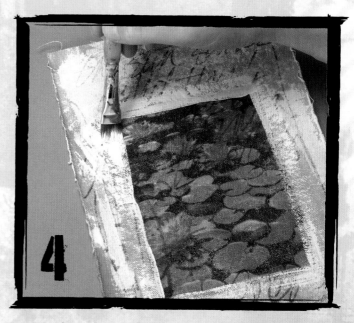

Add border
To make the image blend nicely with the background, lightly add a border with paint and a brush.

Adhering Images with Glue

Create another layer full of visual interest by using glue to attach images or other ephemera to your canvas and painted compositions.

Materials
painted canvas
images on paper
craft glue

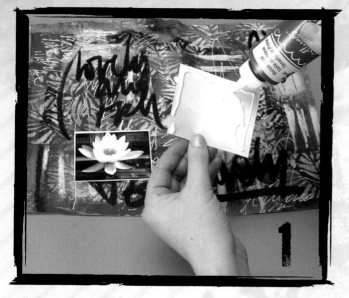

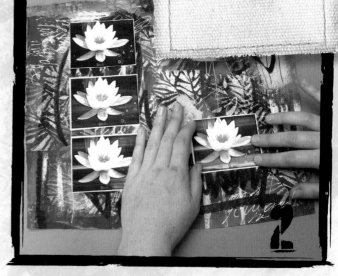

Apply glue
Apply glue to the back of the image, directly from the bottle.

Apply image
Press the image onto the canvas and burnish it down with your fingers.

Adhering Images with a Sewing Machine

Whether you're using a machine or sewing by hand, sewing is another creative way to attach images to your paintings. The durable quality of canvas provides a strong surface that can be sewn without ripping or tearing.

Materials
painted canvas
image on paper
sewing machine

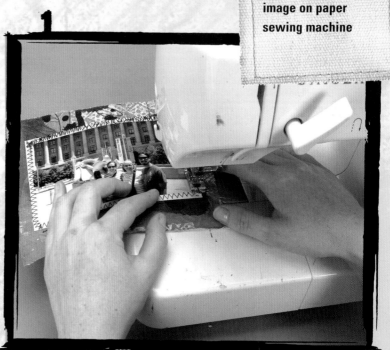

In the Mix
Use different stitches to create lines and patterns around your images.

Sew image to canvas
Thread your sewing machine with the desired color of thread and then sew the image to the canvas, stitching around the perimeter of the paper.

Adhering Images with Paint

Pressing paper and photos directly into thick paint is one of my favorite ways to add images to my compositions. I love the messy look of the paint.

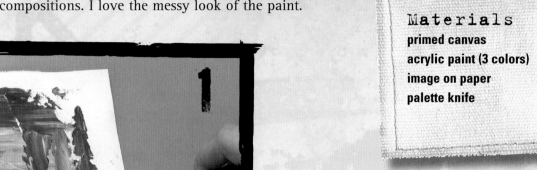

Materials
primed canvas
acrylic paint (3 colors)
image on paper
palette knife

Apply paint
Use a palette knife to apply a generous amount of paint to the canvas.

Apply image
Press your image into the wet paint.

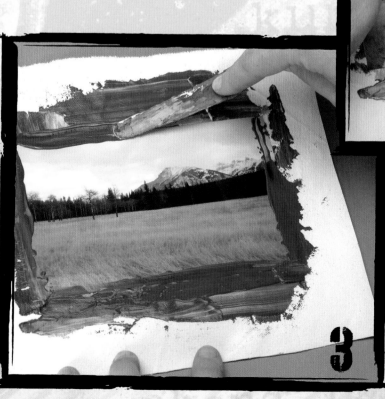

Blend paint
Use the palette knife to gently blend some of the paint over the edges of the photo.

Layering

The best part about all these techniques is putting them all together to create layer after layer of color, texture and meaning. There's something wonderful about an overlay of pattern, words and images, each with a different meaning and appearance.

In the Mix

Combine different techniques. Create many different layers and let small parts of each layer show through.

Layering Spray-Painted Text, Heavy Brushstrokes and Text with Large Marker and Stencils with Acrylic

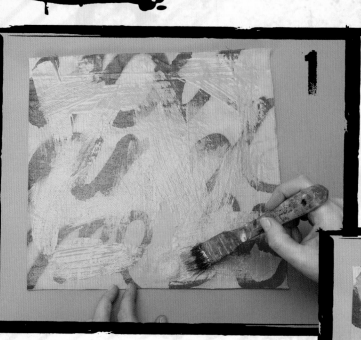

Apply text and brushstrokes
Start with a color-washed canvas (see page 17) and use spray paint to create text on it (see page 27). When it is dry, use a contrasting color and apply large brushstrokes over the canvas.

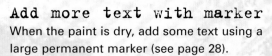

Add more text with marker
When the paint is dry, add some text using a large permanent marker (see page 28).

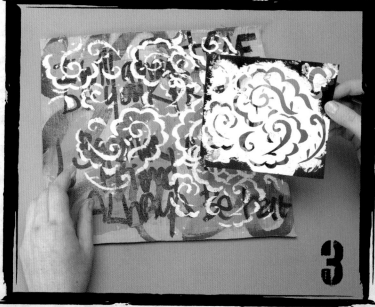

Add paint with stencil
Finally, use a stencil, stencil brush and acrylic paint to add images over the previous layers (see page 29).

Layering Stamping and Text with Watery Paint and Scribbling

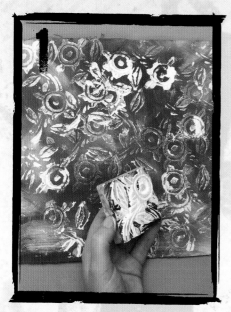

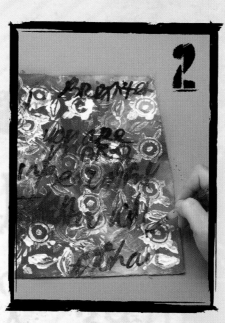

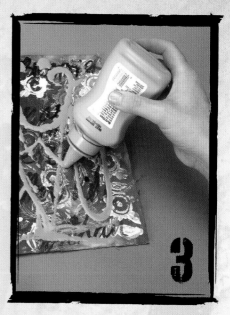

Stamp images
Begin with a color-washed canvas (see page 17). Using a contrasting color of paint to ink your stamp, stamp to cover the canvas (see pages 30–31).

Add text
Now add text over the stamped layer, using a liner brush and watery paint (see page 27).

Scribble paint
Using fluid paint in a condiment container, scribble paint over the previous layers (see page 16).

Layering Scrunching, Shoe Polish Text and Spatter

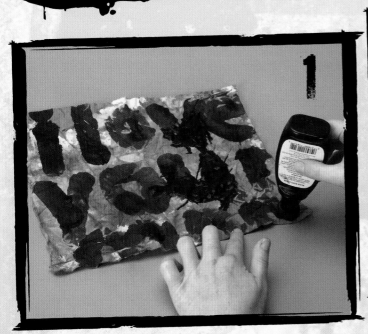

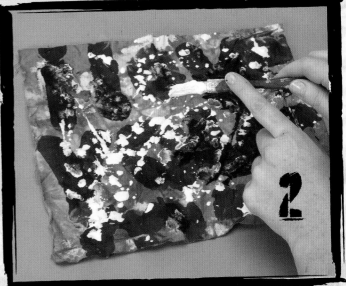

Scrunch and apply text
Apply the scrunching technique to the canvas, using 3 colors of paint (see page 22). When dry, apply text to the canvas using shoe polish (see page 28).

Spatter paint
Spatter a contrasting color over the previous layers (see page 16).

Sealing Canvas

Sealing your canvas painting is one of the most important steps in the process of creating a painting that will be remixed. By applying a layer of polyurethane, you're not only creating a nice glossy finish, you're also waterproofing and protecting your painting.

Seal canvas

Using brushstrokes in a variety of directions, apply a coat of polyurethane to the entire canvas. If you don't want to see any brushstrokes, lightly brush straight across. If, after the canvas is dry, the glossiness is uneven, apply a second coat.

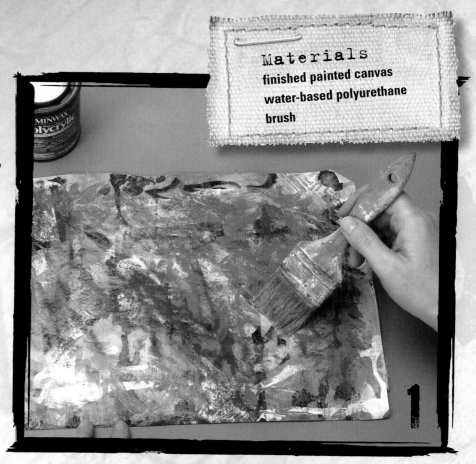

Materials
finished painted canvas
water-based polyurethane
brush

Making Canvas Beads

I've always loved beads in all shapes and sizes. After years of working with canvas, I came up with an idea to create beads from my favorite material. I was thrilled when I figured out how to convert my leftover canvas into rich and colorful art beads. By stringing them onto a long chain, I found that I could create a unique and colorful necklace—and that was just the beginning.

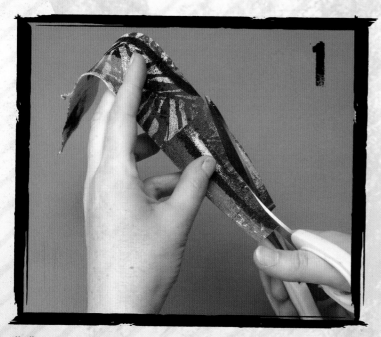

Materials
strips of painted canvas
craft glue
gluing brush
toothpick
scissors

Cut triangle from canvas
Using scissors, cut a long triangle from a strip of canvas.

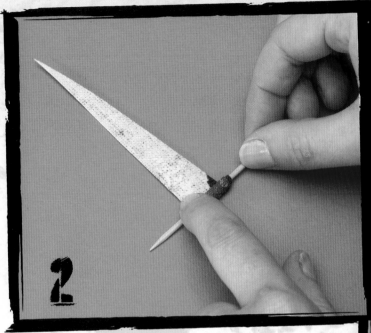

Roll canvas with toothpick
Using the toothpick, begin rolling up the canvas at the wide end.

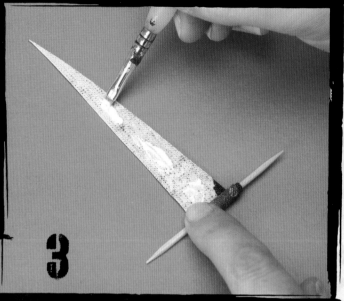

Apply adhesive
Apply a few dots of glue when you're about halfway up.

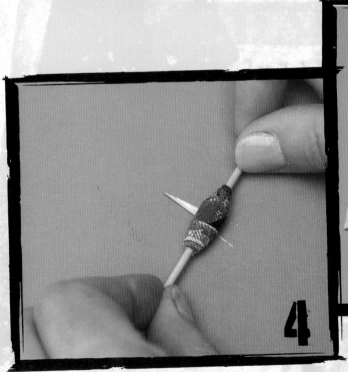

Roll canvas
Roll the toothpick to the end of the canvas, sealing it with glue.

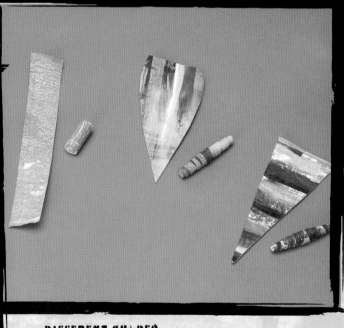

DIFFERENT SHAPES
Here are some other shapes/sizes you can start with and the beads they will make.

No. 60—SUBTRACT

forever be true to yourself

ACCESSORY REMIX

While looking for new and different ways to remix my paintings, I turned to fashion for inspiration. I've always loved expressing myself through clothes and accessories, so creating wearable art came easily. I found myself poring over fashion magazines, perusing department stores (even the expensive ones) and scavenging vintage and antiques shops for jewelry and ideas that would translate into canvas. I experimented with different weights, shapes and textures of canvas and found many ways to transform a painting into something completely different. Through this process I discovered that canvas is so versatile that you can treat it like fabric when sewn and like flexible plastic when glued together and sealed. In this chapter I share my original ideas and simple projects to inspire you to make accessories with paint and canvas. Forget about the mall or spending money on a new pair of earrings; put your creativity to work and remix your creations into wearable art.

Before you get started

- When creating unique accessories, pull inspiration from fashion trends. For example, if purple and green are all the rage for winter, use these colors in your painted canvas so you can remix them into accessories that fall in line with the season's trends.
- Look for interesting shapes around you. Shapes you find in architecture, furniture and nature can translate into the shapes used in jewelry.
- Incorporate found objects and vintage finds into your canvas accessories. A unique chain, bead or embellishment is all you need to take your canvas to the next level.
- Find inspiration in your closet. Take a good look at your wardrobe and invent accessories that will brighten, create interest and set you apart from everyone else!

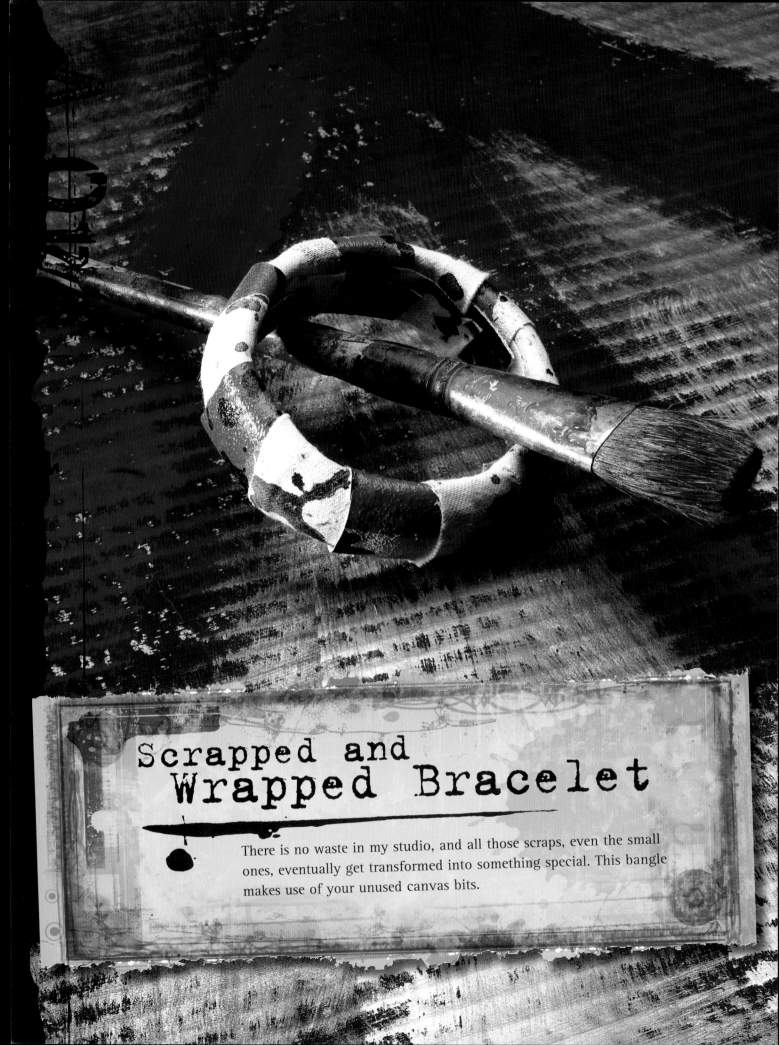

Scrapped and Wrapped Bracelet

There is no waste in my studio, and all those scraps, even the small ones, eventually get transformed into something special. This bangle makes use of your unused canvas bits.

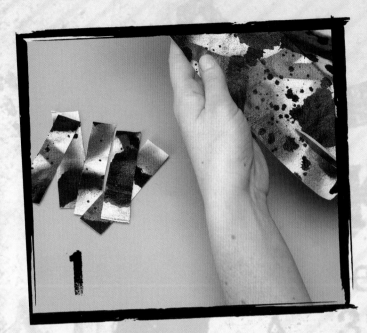

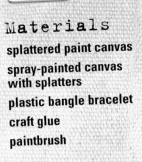

Materials

- splattered paint canvas
- spray-painted canvas with splatters
- plastic bangle bracelet
- craft glue
- paintbrush

Cut canvas

Cut both types of canvas into strips that are approximately 1" × 3" (3cm × 8cm).

Cover bracelet with glue

Apply glue to a section of the bracelet with a brush. Coat the inside as well as the outside.

Adhere canvas to bracelet

Begin adhering the strips, alternating canvases, so the strips overlap on the inside. Trim the strips as needed so they don't show.

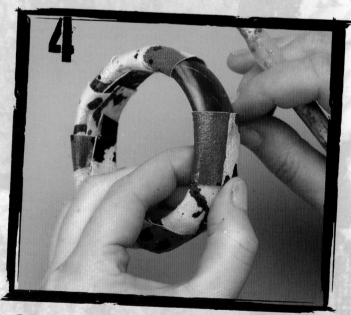

Repeat until finished

Continue around until the bracelet is covered.

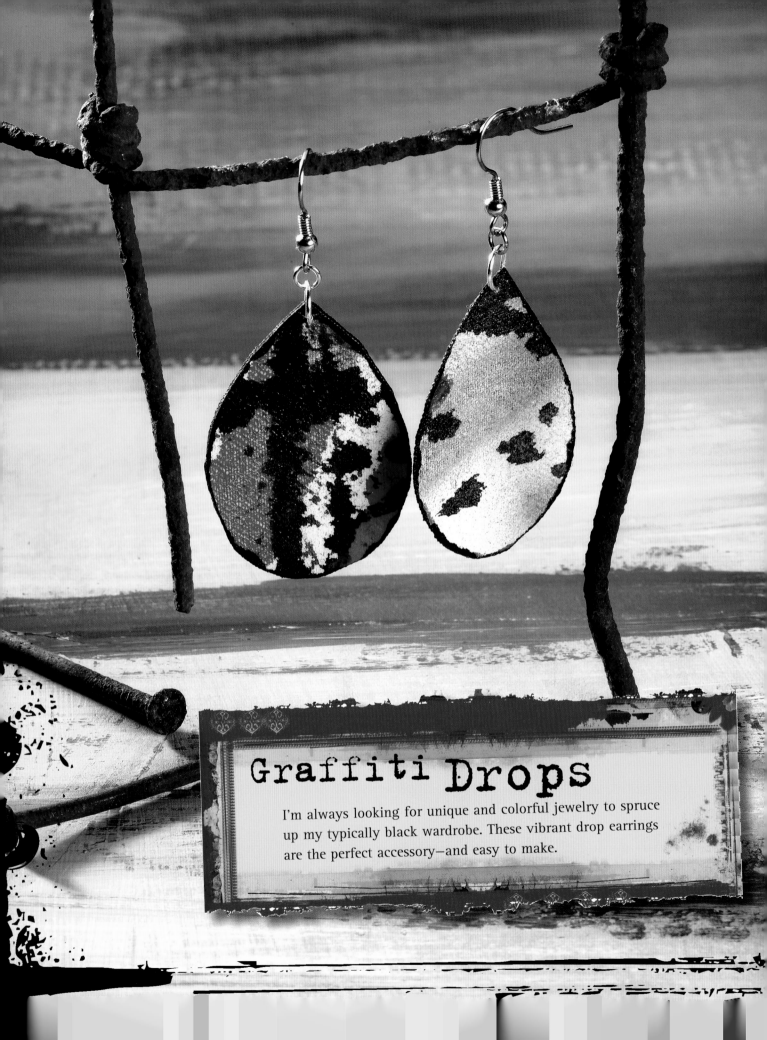

Graffiti Drops

I'm always looking for unique and colorful jewelry to spruce up my typically black wardrobe. These vibrant drop earrings are the perfect accessory—and easy to make.

Materials

- painted canvas scrap
- acrylic paint (1 color of choice plus black)
- water-soluble polyurethane
- paintbrushes (1 for paint and 1 for polyurethane)
- permanent marker
- 2 earring hooks
- 4 jump rings
- awl
- scissors
- pliers

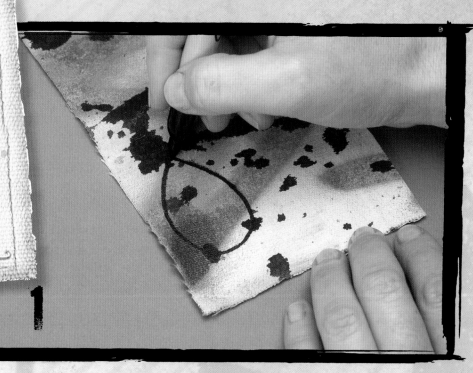

Draw shape
Using a marker, freehand draw a shape on the canvas.

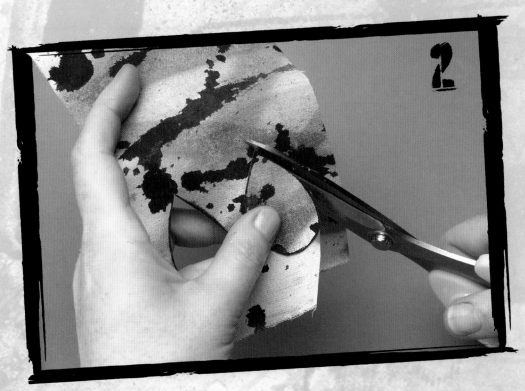

Cut shape
Cut the shape from the canvas. Then, use it as a template to cut out a second, identical shape.

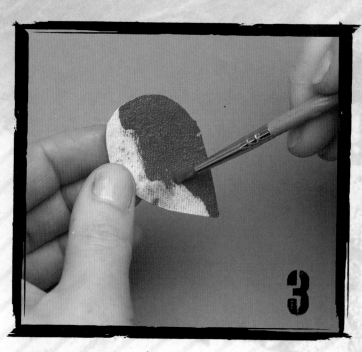

Paint backs

Paint the backs of the shapes with a solid coat of acrylic paint.

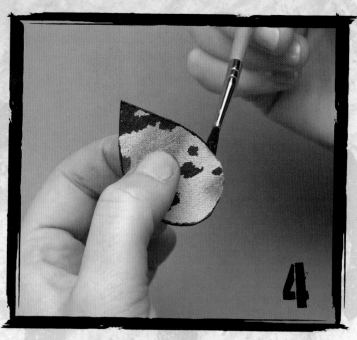

Paint edges

Paint the edges of each shape with black paint. Let them dry.

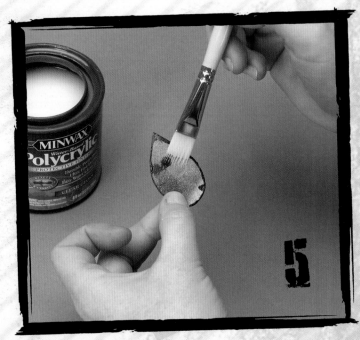

Seal earrings

Use a brush to give each piece a coat of polyure-thane. Let them dry.

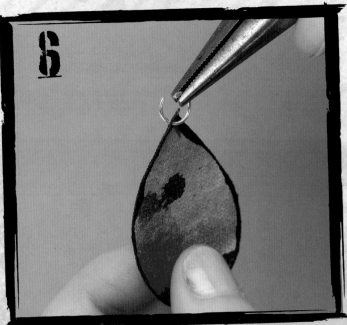

Attach jump ring

Use an awl to create a small hole at the top of each piece. Using the pliers, attach a jump ring to each shape.

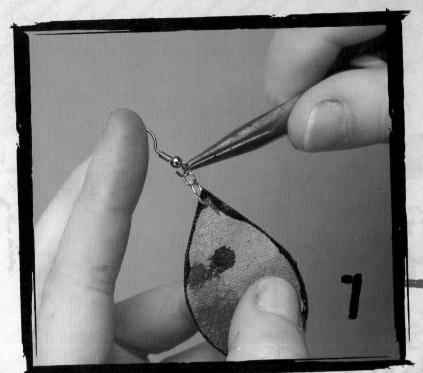

Add earring hook

Add a second jump ring to each of the first jump rings, then attach the second jump rings to the earring hooks.

1

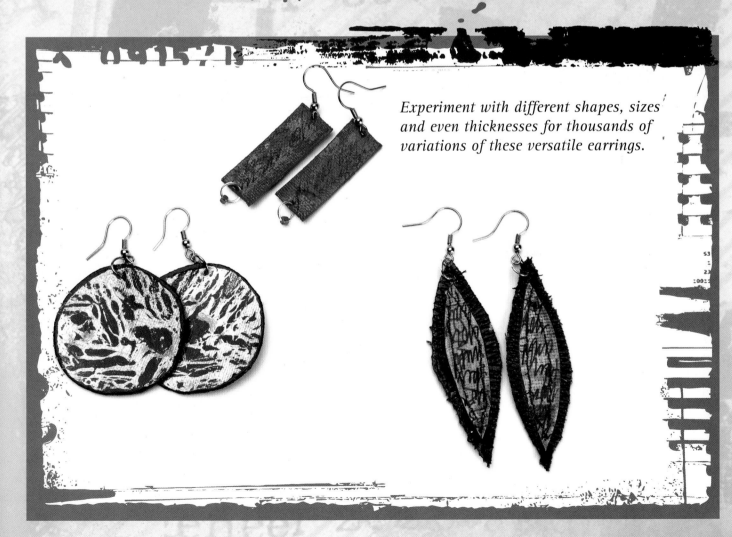

Experiment with different shapes, sizes and even thicknesses for thousands of variations of these versatile earrings.

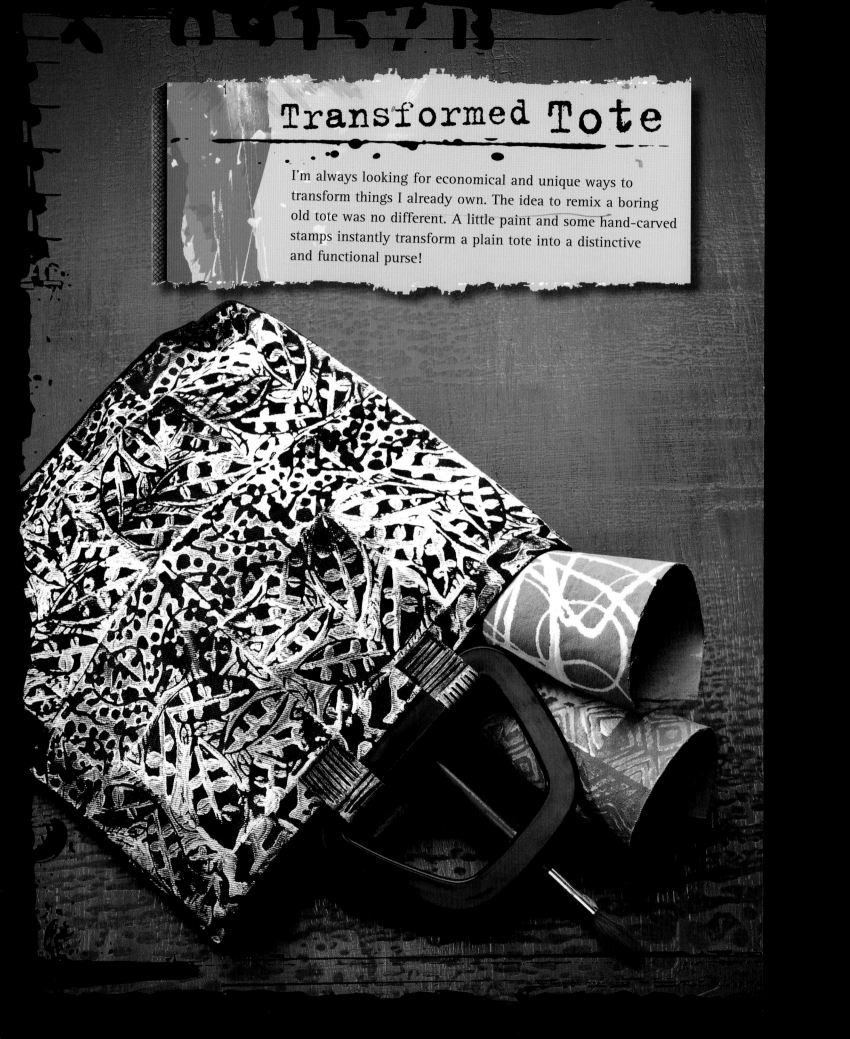

Transformed Tote

I'm always looking for economical and unique ways to transform things I already own. The idea to remix a boring old tote was no different. A little paint and some hand-carved stamps instantly transform a plain tote into a distinctive and functional purse!

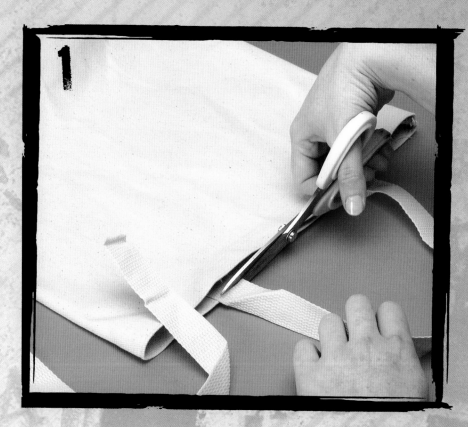

Materials

plain canvas tote bag
primed canvas
acrylic paint (2 colors)
water-soluble polyurethane
paintbrush
2 lacquer handles
fabric glue
stamp(s)
sewing machine
scissors

Remove handles

Cut the handles off the store-bought bag.

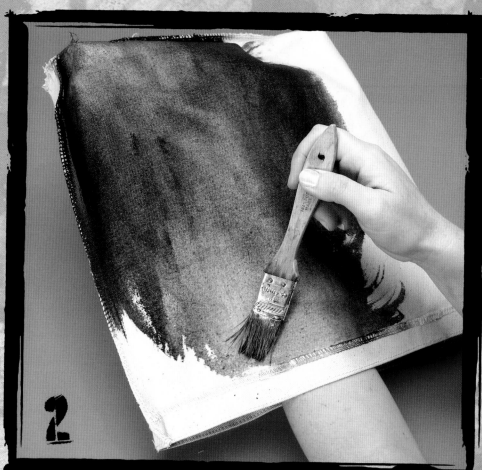

Color-wash inside of bag

Turn the bag inside out and give it a wash of your chosen color. Let it dry.

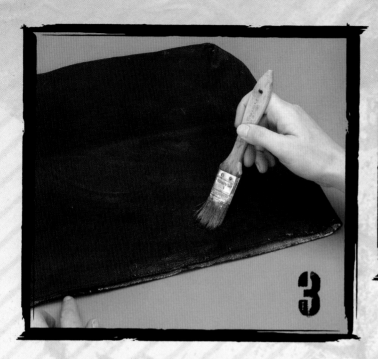

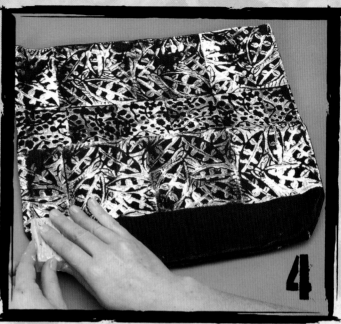

Paint outside of bag

Turn the bag right-side out and apply a
solid coat of paint to the outside.

Stamp bag

Using 1 or 2 stamps and a contrasting color of paint,
create a pattern over the entire surface of 1 side of the
bag. Use the flexibility of the stamp to work the image
into the unevenness of the bag's surface. Let it dry,
then repeat for the other side of the bag.

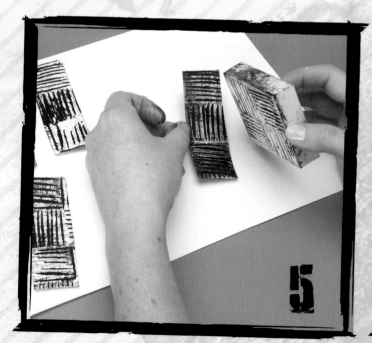

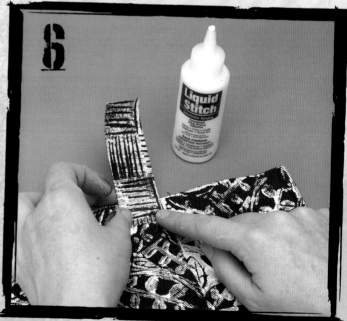

Cut and stamp strips

Cut 4 strips of canvas to 3½" × 1¼" (9cm × 3cm), and
paint both sides of both pieces in the primary color.
When they're dry, stamp over them with the
contrasting color.

Attach strips to bag

Position a canvas strip from step 5 on the outside
of the bag where you removed the tote's handle
in step 1. Use fabric glue to adhere 1 end of the
canvas strip to the tote. Repeat with another can-
vas strip on the same side of the tote.

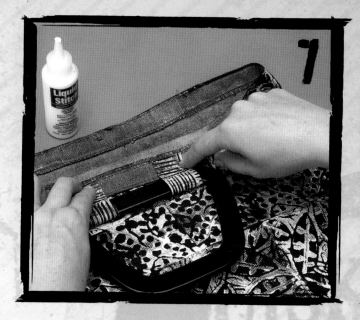

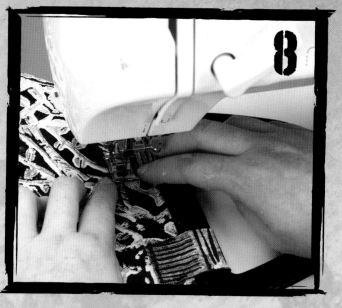

Attach handle

When the glue has set, fold the strips around the first handle, and glue the strips on the inside of the bag.

Repeat and finish

Repeat for the other side and handle. Then, reinforce the handles by using a sewing machine to sew the strips securely in place.

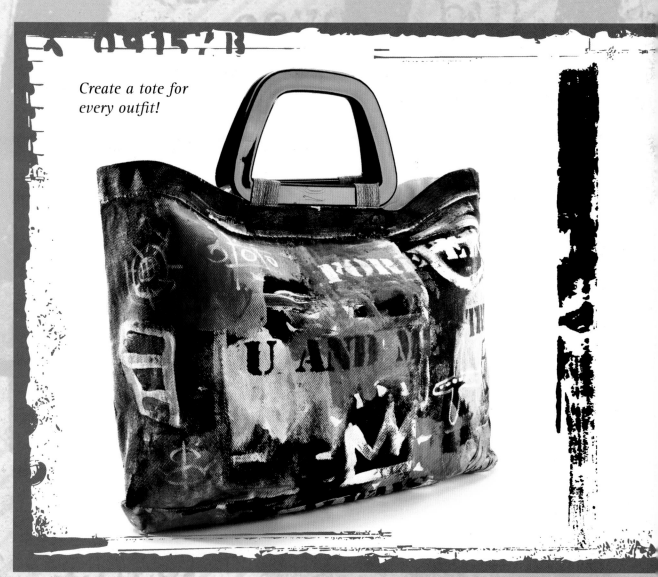

Create a tote for every outfit!

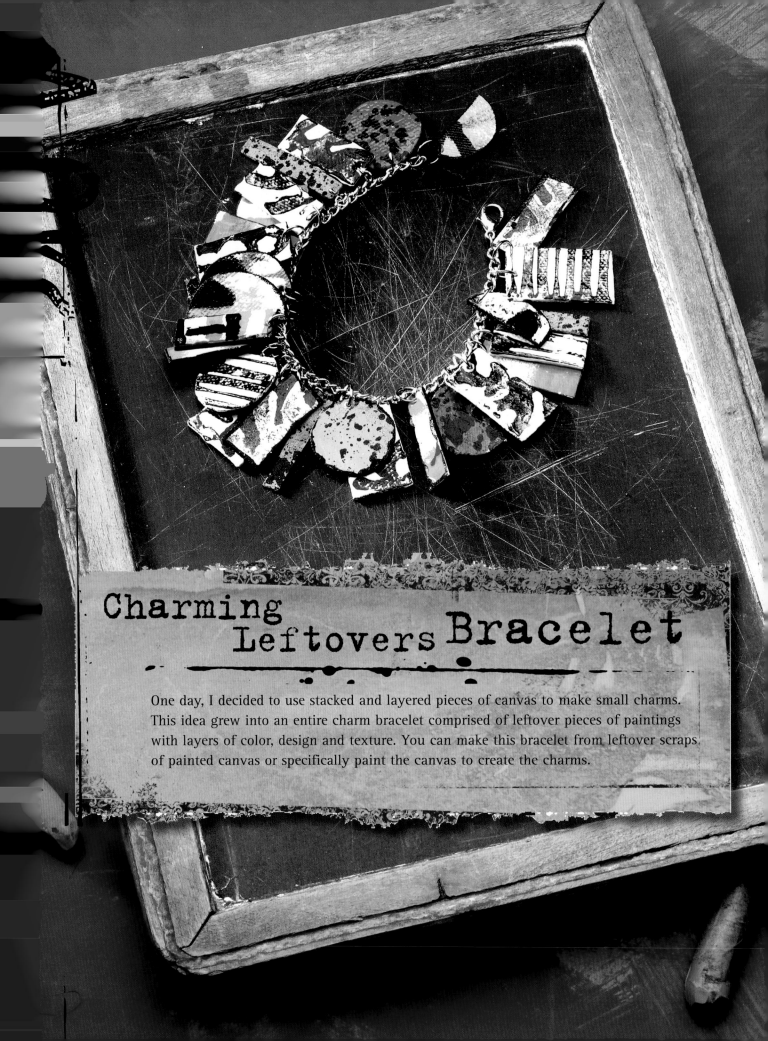

Charming Leftovers Bracelet

One day, I decided to use stacked and layered pieces of canvas to make small charms. This idea grew into an entire charm bracelet comprised of leftover pieces of paintings with layers of color, design and texture. You can make this bracelet from leftover scraps of painted canvas or specifically paint the canvas to create the charms.

Materials

- painted canvas (in 6 styles of your choice)
- acrylic paint (black)
- water-based polyurethane
- paintbrushes
- silver chain
- lobster clasp
- 25–30 jump rings
- craft glue
- awl
- pliers
- wire cutters
- scissors

Glue canvas and cut shapes

Glue 2 canvas pieces together, back-to-back. Repeat 2 more times to create a total of 3 double-sided pieces. Use scissors to cut out a variety of shapes and sizes, including circles, squares, rectangles and half-circles. Cut out a total of 25–30 shapes.

Paint edges

Paint the edges of some of the pieces with black paint. Let them dry.

Seal pieces

Apply a coat of polyurethane to both sides of each piece. Let it dry.

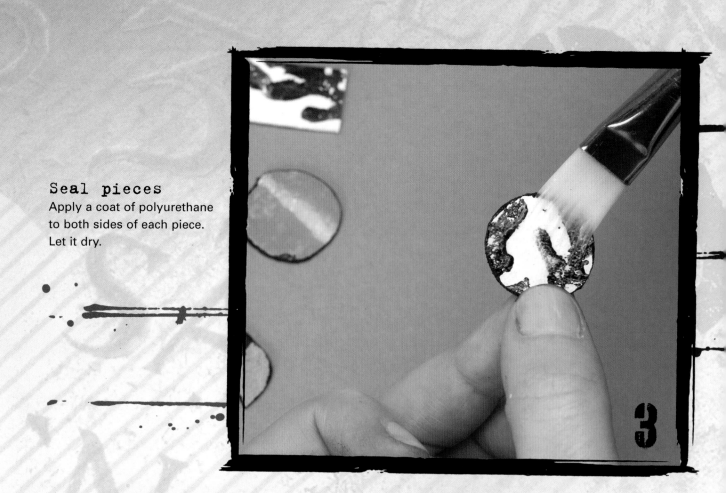

3

4

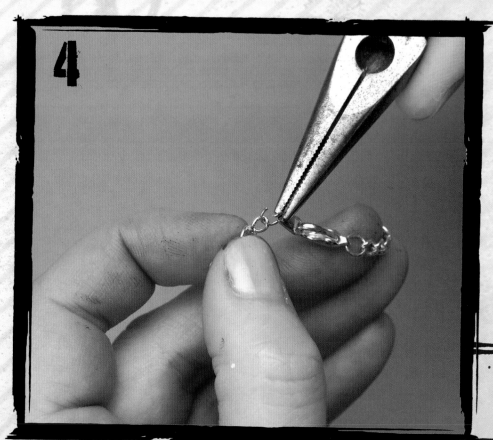

Cut chain and add clasps

Use wire cutters to cut a piece of silver chain to the length you'd like your bracelet to be. Using pliers, attach each half of a lobster clasp to the 2 ends.

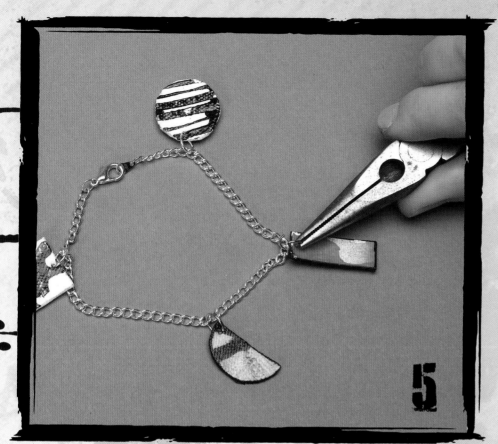

Attach charms

Use an awl to create a hole at the top or end of each canvas shape, and insert a jump ring through the hole of each. Beginning at 1 end of the chain, start attaching the charms to the links of the chain. (Not every link needs a charm; use as many or as few as you'd like.)

5

6

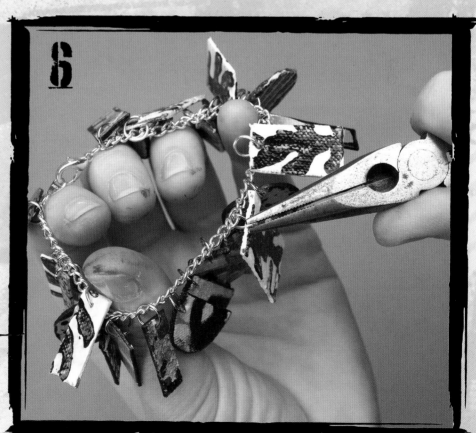

Continue adding charms

Continue along the entire length of the chain until your bracelet is complete.

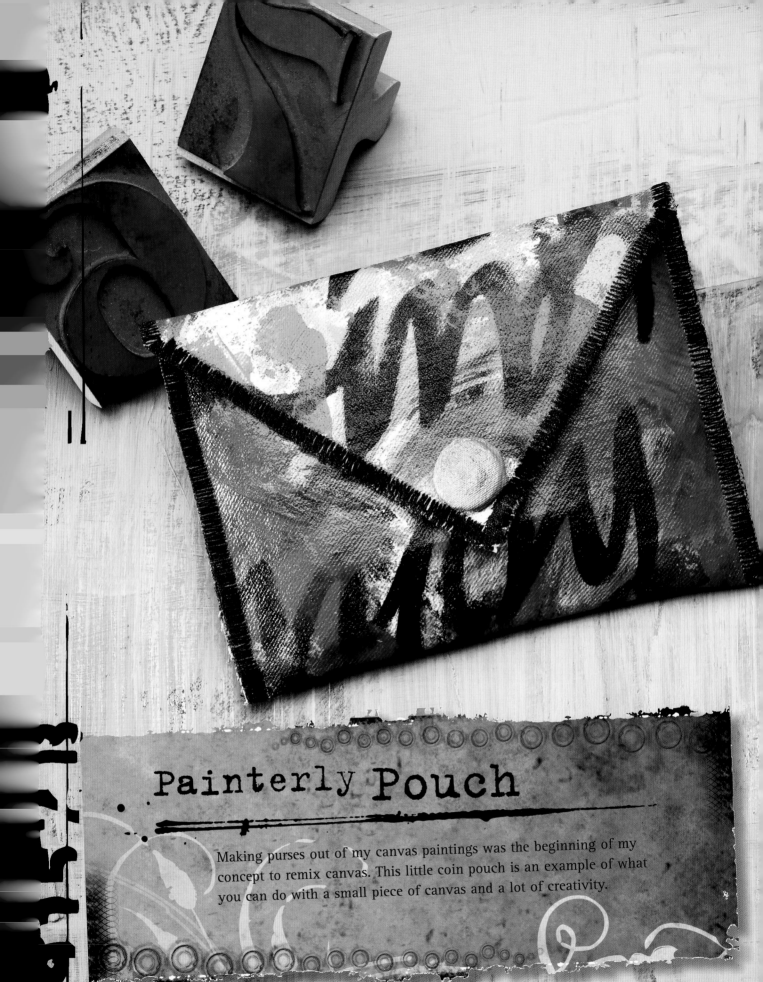

Painterly Pouch

Making purses out of my canvas paintings was the beginning of my concept to remix canvas. This little coin pouch is an example of what you can do with a small piece of canvas and a lot of creativity.

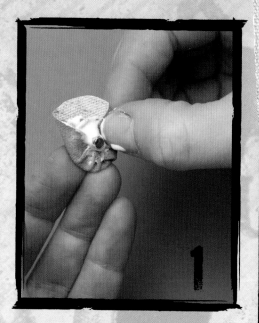

Materials

canvas painted with large brushstrokes and text (stamped on reverse side)

scrap of coordinating canvas

water-soluble polyurethane

paintbrush
snap
snap setter
hammer

sewing machine
scissors
craft glue

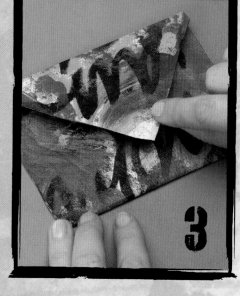

Cut canvas and add snap

Cut out a circle of scrap canvas that is about ¼" (6mm) larger all the way around than the top half of the male part of the snap. Glue the snap to the back of the fabric and then fold the edges over and secure them with more glue. Set this aside.

Cut envelope from canvas

Create an envelope shape on the canvas and cut it out with scissors.

Fold

Fold the shape up like an envelope and crease it well.

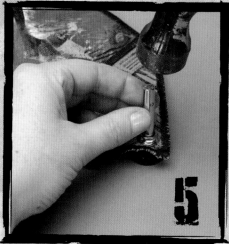

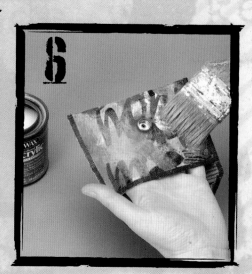

Sew edges

Use a sewing machine to sew a dense zigzag stitch along the end of the envelope, opposite the pointed end. Then start just above the fold and sew the front and back of the pouch together. Continue up along the point of the flap, down the other side of the point and, finally, down the other side of the pouch.

Attach snap

Using a snap setter and hammer, set the covered half of the snap at the point in the flap and the other half where it would join the pouch.

Seal pouch

Apply a coat of polyurethane to the entire outside of the pouch. Brush right over the stitching—it won't hurt it.

Artful iPod Case

I constantly drop and spill water on my digital music player.
Protect your music while making an artistic statement with a case
that's made completely from brightly painted canvas.

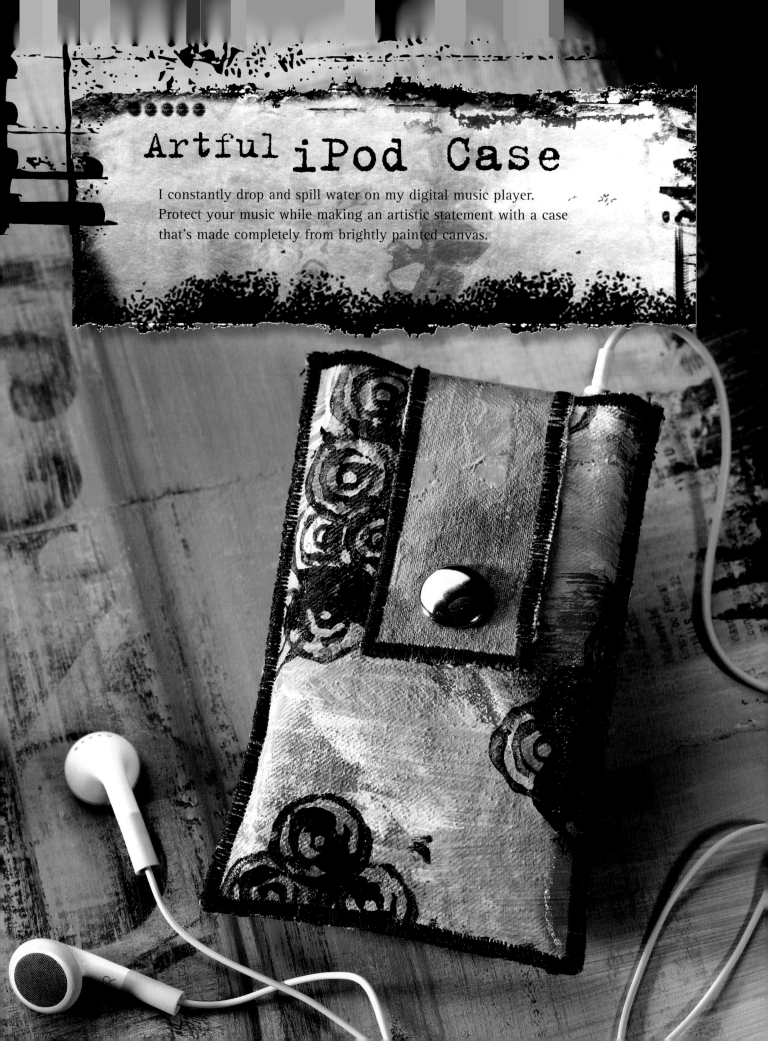

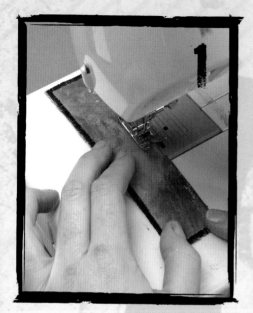

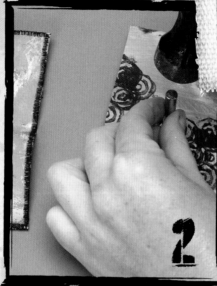

Materials

canvas painted with brushstrokes and stamps [2 3½" × 5" (9cm × 13cm) pieces and 1 1½" × 5½" 94 cm ×14cm)]

water-soluble polyurethane

paintbrush

snap

snap setter

hammer

sewing machine

scissors

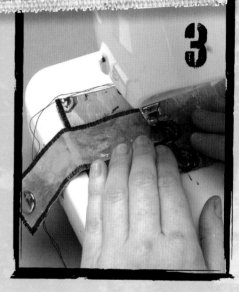

Sew back piece

Cut 2 pieces of the canvas to 3½" × 5" (9cm × 13cm) each and a strip to 1½" × 5½" (4cm × 14cm). With the sewing machine, sew a zigzag stitch around the edges of the 1½" × 5½" (4cm × 14cm) strip.

Sew case and add snap

Sew along the top edges of the 3½" × 5" (9cm × 13cm) pieces. Set the top half of the snap into 1 end of the strip. Fold the strip in half, and position it over the other 2 pieces at the stitched tops; mark where the bottom half of the snap should go. Set this half in what will become the front of the case.

Sew back piece to case

Sew the strip to the back piece of the case where it meets the case when it's folded over the top.

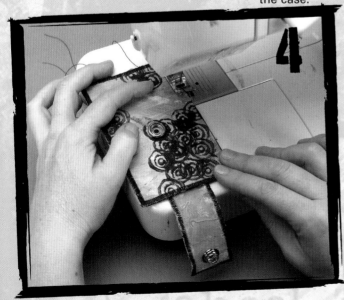

Sew case sides

Sew the 3 sides of the case together.

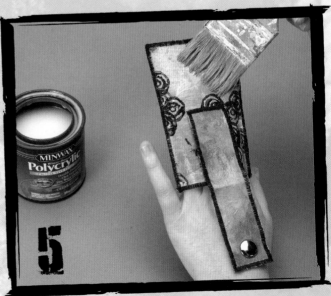

Seal case

Apply a coat of polyurethane to the entire case.

forever be true to yourself

7

Expressions Cuff Bracelet

There's nothing like a thick cuff bracelet to add a little rock and roll to your wardrobe. Use this painted accessory to express yourself and your thoughts!

Materials

2 contrasting pieces of painted canvas

printer-compatible canvas sheet

computer with word-processing software

ink-jet printer

felt

snap

snap setter

awl

scissors

sewing machine

hammer

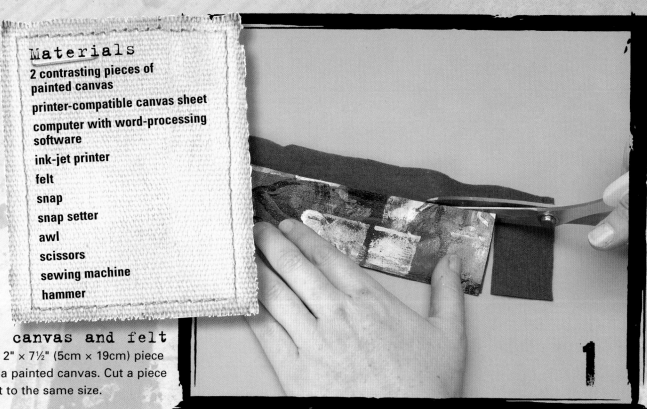

Cut canvas and felt

Cut a 2" × 7½" (5cm × 19cm) piece from a painted canvas. Cut a piece of felt to the same size.

Print and lay out text

Print a phrase on a piece of printer-compatible canvas according to the manufacturer's instructions, and cut it into a strip that is about ¾" (2cm) wide. Cut a strip from the other piece of painted canvas that is about 1¼" × 7" (3cm × 18cm). The text strip and the second strip can be somewhat irregular in shape. Lay out the pieces as desired.

forever be true to yourself

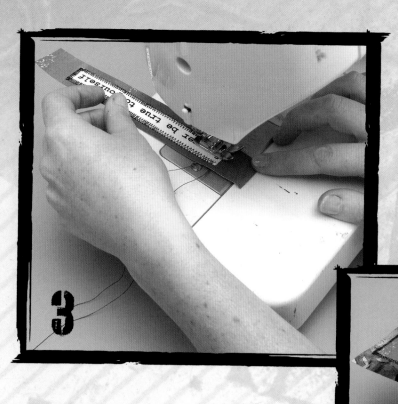

3

Sew text to canvas
Use a zigzag stitch to sew the text strip onto the middle strip.

Sew canvas strips together
Continue sewing, attaching the middle strip to the large strip.

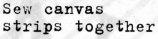

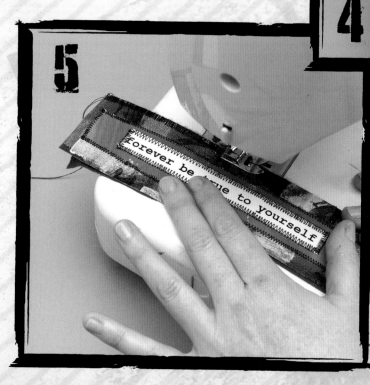

4

5

Sew felt to canvas
With a zigzag stitch around the outside, sew the felt to the large painted strip.

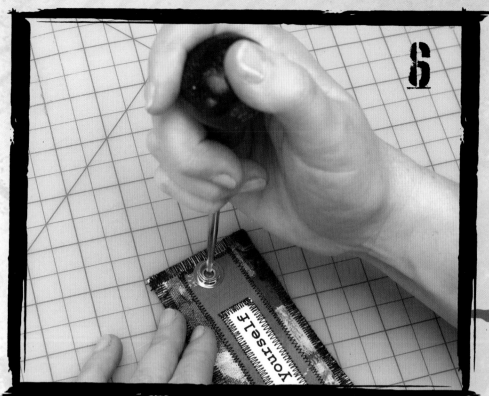

Mark cuff for snap

Using the snap pieces as a guide, use an awl to mark the holes where you want the snaps to go.

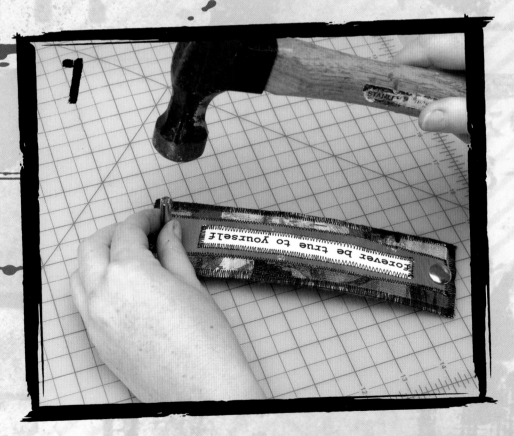

Add snap

Use the awl to make holes that are big enough to accommodate the snaps. To make the holes clean, snip excess fabric away with scissors. Finally, use the snap setter to set the snaps in the holes.

Canvas-Jewels Necklace

I've always loved beads in all shapes and sizes. After years of working with canvas, I came up with an idea to create beads from my favorite material. I was thrilled when I figured out how to convert my leftover canvas into rich and colorful art beads.

Materials

assortment of canvas beads
assortment of commercial beads
silver chain
20–30 2" (5cm) eye pins
round-nose pliers
wire cutters

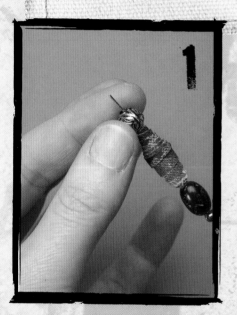

Thread beads

Cut a segment of chain to about
6" (15cm). On an eye pin, thread a
small commercial bead, a canvas
bead and a commercial bead.

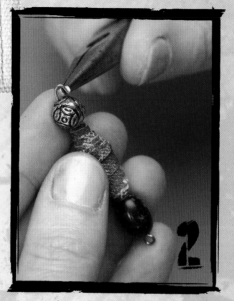

Create loop

Using pliers, make a loop at the end
of the eye pin.

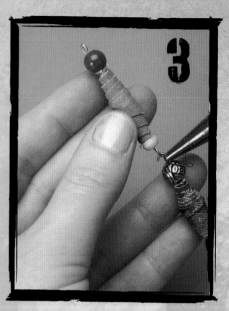

Create and attach
second dangle

Create a second piece with a new
eye pin and beads, and attach it to
the first piece.

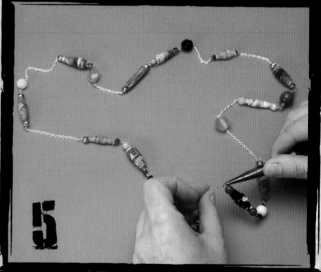

Add dangles and finish

Continue in a random fashion, alternating segments
of chain, beads and sometimes eye pins without can-
vas beads—just commercial beads. When the neck-
lace is as long as you'd like it, connect the two ends
together to finish.

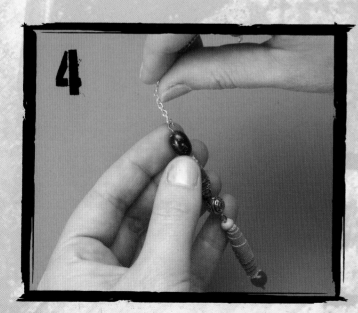

Attach chain

Attach the dangle to one end of the chain.

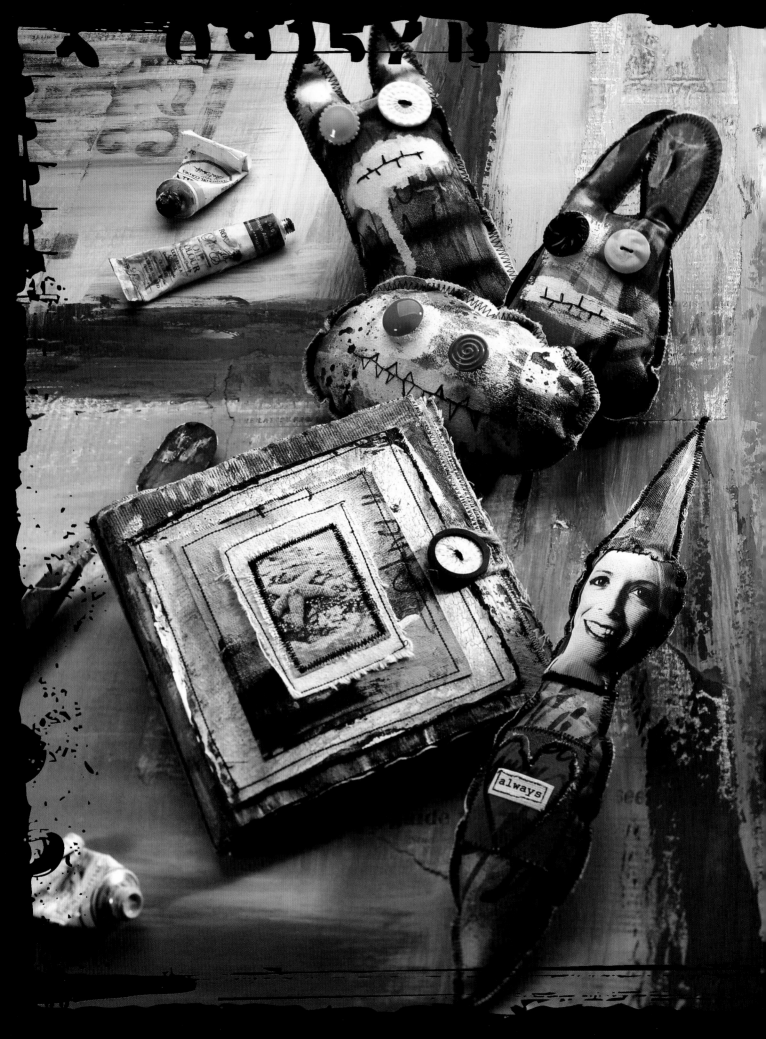

EXPRESSION REMIX

There's something so raw about expression just for the sake of expression. As a painter, I've found it gets tiresome creating things to sell or put on a wall, and often I hit a creative block and run out of ideas. During these times, it's really important for me to have fun with my art and make things purely out of pleasure for the process. It seems that when I'm alone in my studio goofing around with canvas and paint, I usually stumble upon the best ideas for fun projects. Paint and canvas are the perfect materials for experimenting with self-expression. You can glob, splatter and layer your way into a whole new way of thinking about the things you make. From canvas creatures to painted journals, this chapter will introduce you to a handful of fun projects that I hope will bring a little joy to your creative process!

Before you get started

- *Commit a block of time just for playful creation. Don't put too much planning into this process; just let your paint and canvas speak to you!*

- *Explore your materials. Pick one technique or tool to experiment with, and gain a better understanding of how best to utilize it.*

- *Be open to experimentation. Instead of trying too hard to make something perfect, dedicate yourself to making something from start to finish.*

- *Brainstorm! Keep your project ideas and thoughts in a journal. If you hear or see something that sparks an idea, write it down for later.*

- *Look for inspiration at museums, galleries and even small boutiques, which can offer new ways of looking at art and ideas for what to create next.*

Embellished Canvas Cards

Creating a handmade greeting card is one of the easiest ways to show someone you care. You don't have to limit your cardmaking supplies to paper, incorporate canvas embellishments into your card projects!

Materials

- piece of solid-colored painted canvas
- piece of stamped canvas
- folded card
- craft glue
- paintbrush
- sewing machine

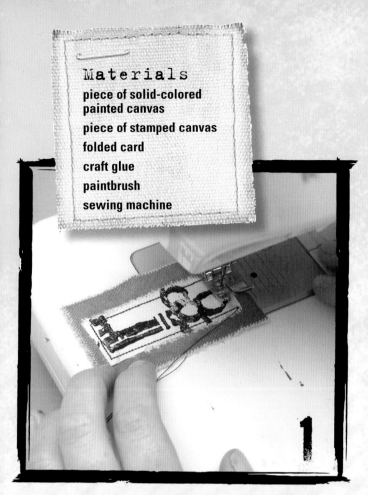

Rip and sew canvas

Rip a 2" × 3½" (5cm × 9cm) piece from the solid-color canvas and a 1½" x 3" (4cm × 8cm) piece from the stamped canvas. Sew the stamped piece to the other piece, using a sewing machine and a straight stitch.

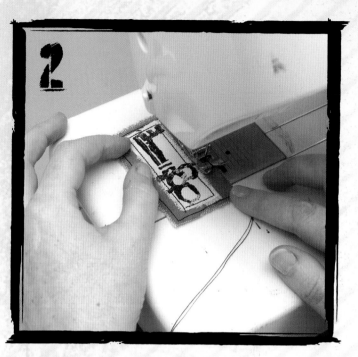

Create border

Sew a border (straight stitch) around the outside piece.

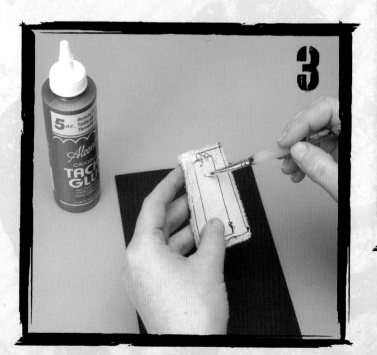

Apply glue

Using a brush, apply glue to the back of the canvas piece.

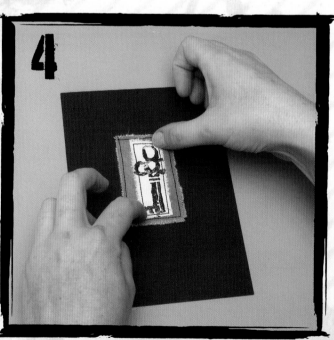

Glue to card

Adhere the piece to the front of the card with glue.

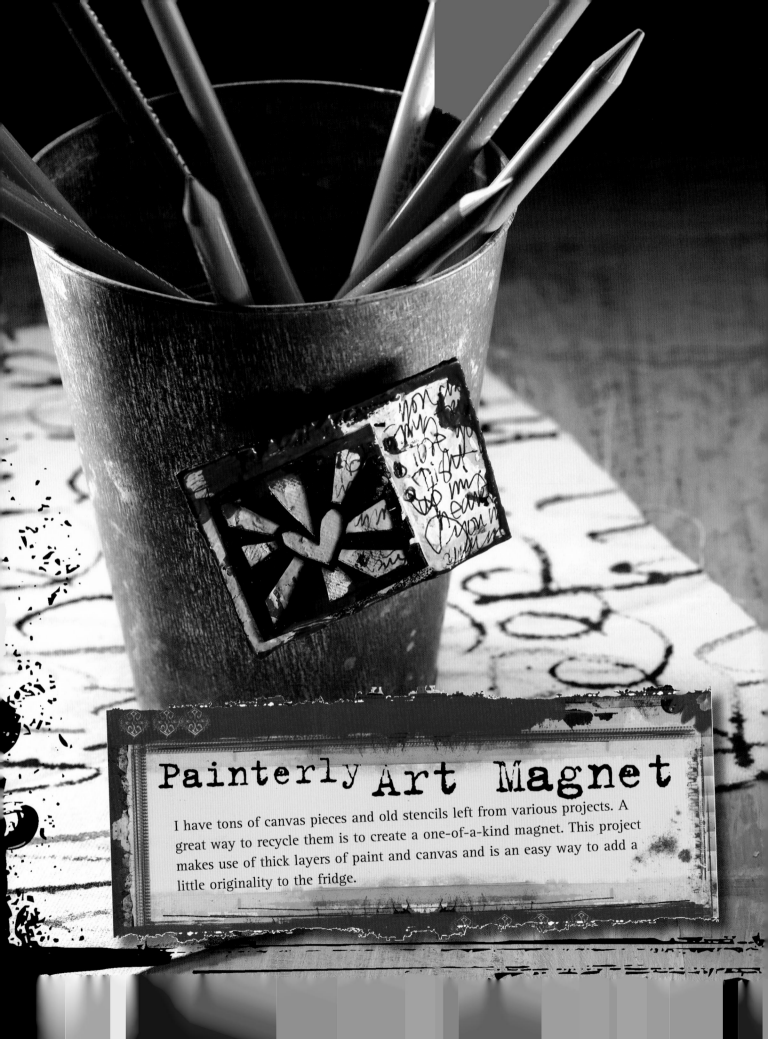

Painterly Art Magnet

I have tons of canvas pieces and old stencils left from various projects. A great way to recycle them is to create a one-of-a-kind magnet. This project makes use of thick layers of paint and canvas and is an easy way to add a little originality to the fridge.

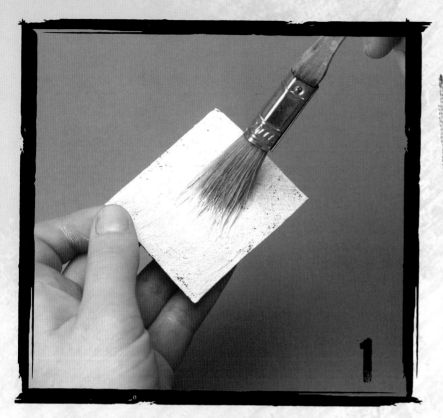

Glue canvas together and paint

Cut 2 pieces of primed (or scraps of painted) canvas to approximately 1½" x 2½" (4cm x 6cm). Glue them together, back to back. Paint 1 side white. Let it dry.

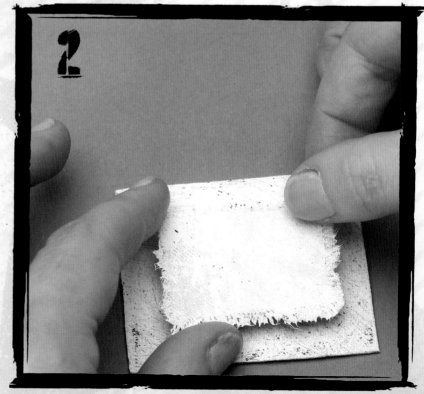

Glue canvas to square

Cut or rip a scrap of canvas to a sizee slightly smaller than the first piece, and adhere it to the white side of the first piece, using craft glue.

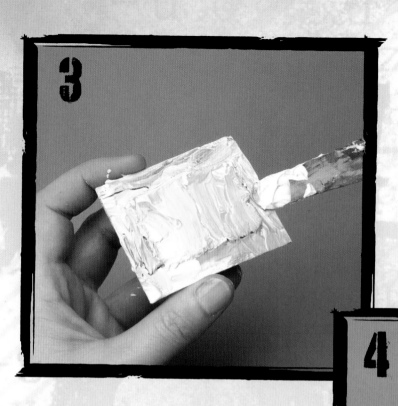

Paint

Using a palette knife, crudely smear some paint over the piece. This can be as random as you like—have fun with it.

Add stencil

While the paint is still wet, stick the stencil into it as an embellishment.

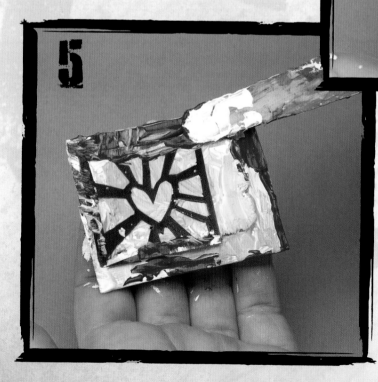

Paint border

Apply an accent color in just a few spots. This also helps to smooth down the stencil.

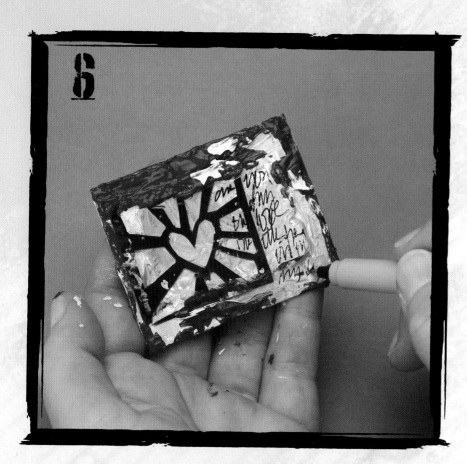

6

Add text
With a fine-point permanent marker, add some text to a light or white area. Let it dry.

7

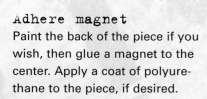

Adhere magnet
Paint the back of the piece if you wish, then glue a magnet to the center. Apply a coat of polyure-thane to the piece, if desired.

Bold Blooms

Inspired by my local flower market, this project transforms simple canvas pieces into bold and unique flowers. Turn them into fashion pins or gift toppers, or string them together to create garland or even an alternative wreath.

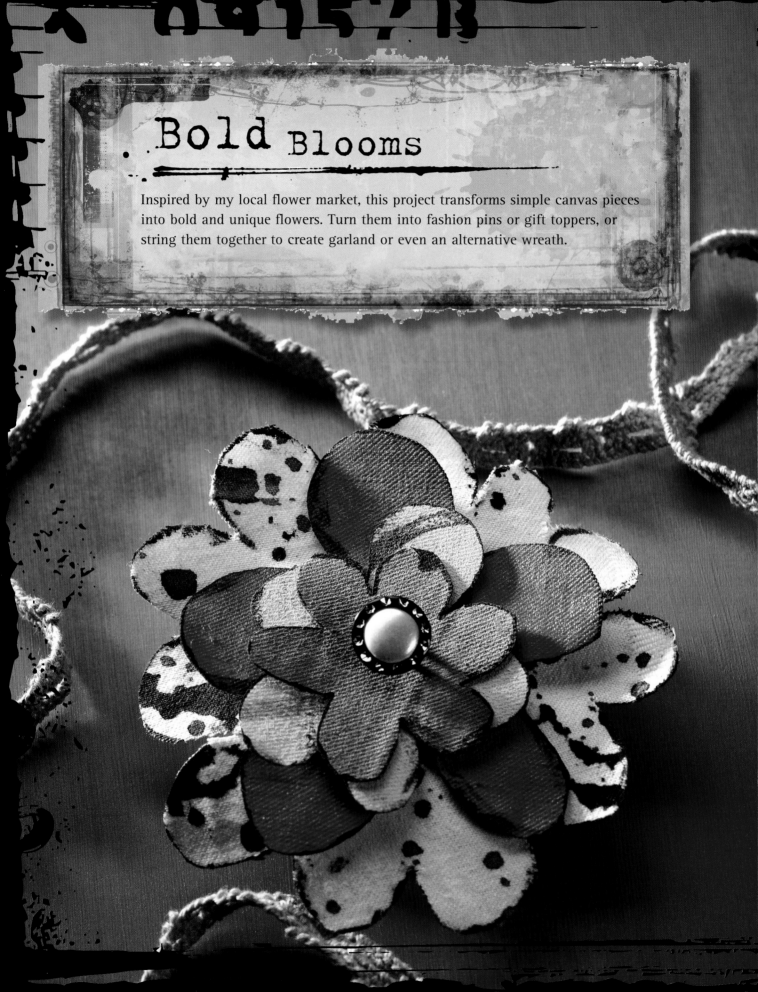

Materials

- scrap of canvas splattered with paint
- scraps of solid-colored painted canvas
- scrap of canvas with scribbles
- acrylic paint (black)
- paintbrush
- scrap paper
- paper
- pen
- needle
- button
- thread
- scissors

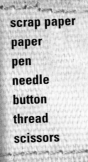

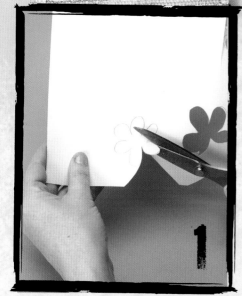

Create templates
Draw 4 flower shapes in descending sizes on a piece of scrap paper, then cut the shapes out with scissors. Vary the number of petals on each.

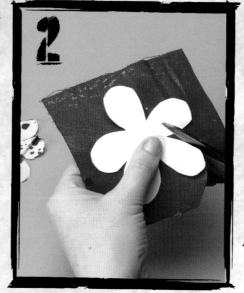

Cut flowers from canvas
Use the cut-out flowers as templates to cut shapes from the canvas—
1 flower from the splattered scrap,
2 flowers in different solid colors and
1 flower from the scribbled scrap.

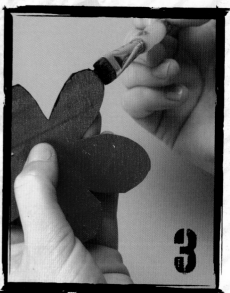

Paint edges
Using a brush, lightly dab black paint around the edges of the petals for some definition.

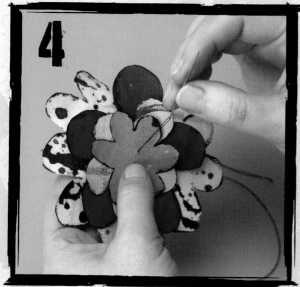

Sew petals together
Repeat these steps for each flower and let them dry. Thread a needle and stack the flower pieces together in ascending order. Sew the stack together from the back.

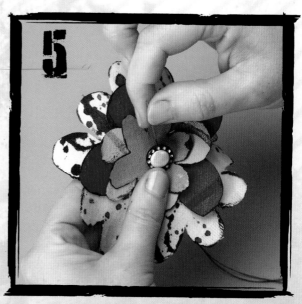

Add button
Sew a button in the center to finish.

Canvas Memoirs

A simple photo book made completely from canvas is the perfect alternative to a typical scrapbook. The canvas pages allow for layers of messy paint, stamps and sewn photos. I like to carry mine with me to use for writing and sketching on top of the messy pages. Each one is like a miniature painting when it's finished.

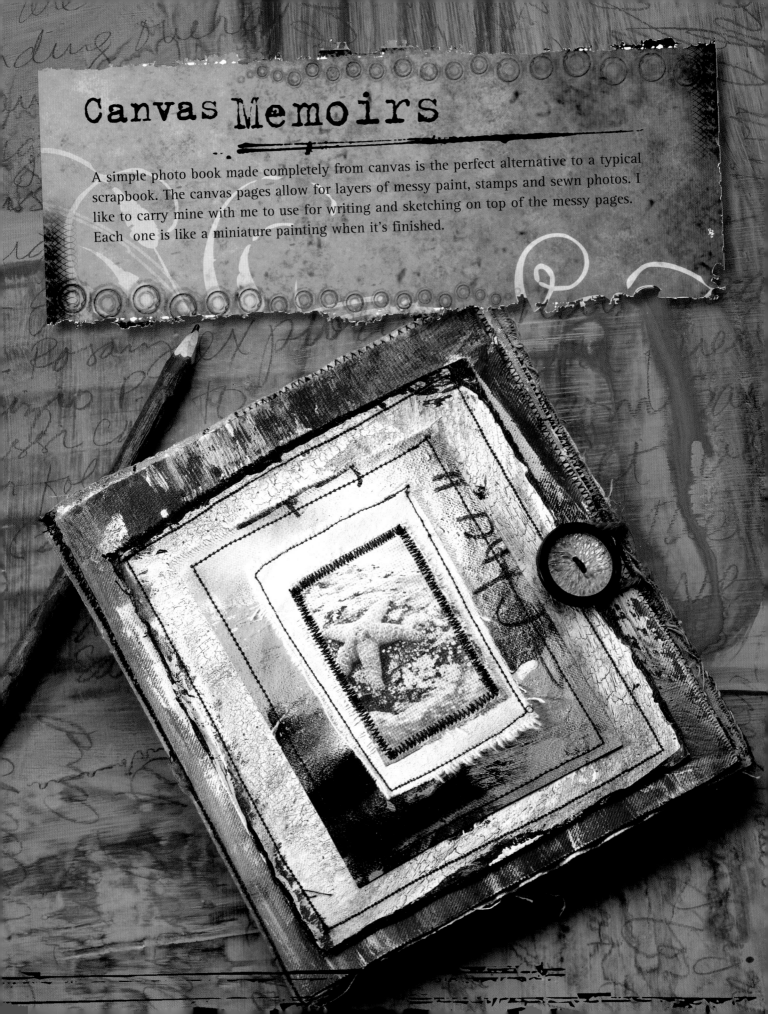

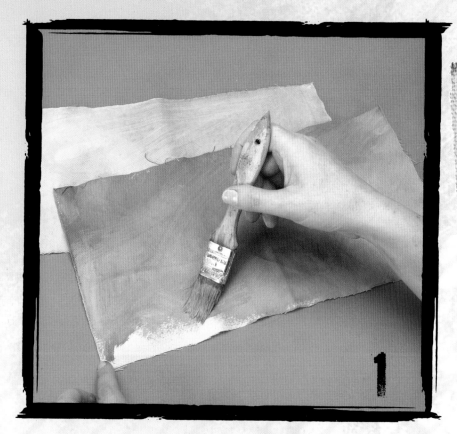

Materials

unprimed canvas

painted canvas scraps

acrylic paint (assorted colors)

paintbrush

photos printed on ink-jet-compatible canvas sheets or raw canvas

hemp twine, 20" (51cm)

large button

sewing machine

Cut and prime canvas

Cut 8 pieces of canvas to whatever size you'd like your book to be. (The pieces can be the same size, or all different sizes, but paint both sides of the canvas, letting the paint dry after each coat.) Here, my pieces are 8" × 13" (20cm × 33cm). Paint both sides of all of the pieces with a solid color paint. Here, I am using a variety of colors that remind me of the ocean.

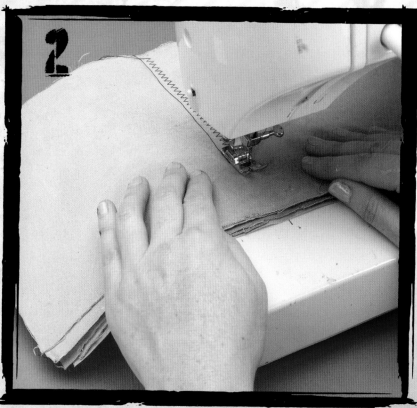

Stitch canvas together

Stack the pices of canvas and use a sewing machine to stitch them together down the center.

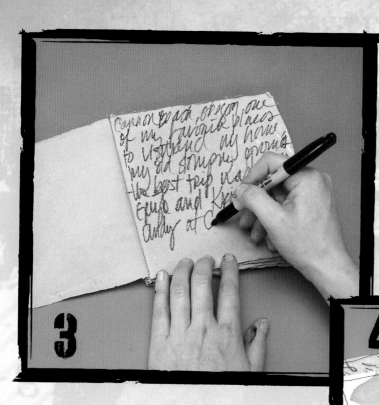

3

Prepare photos and journal
Crop your photos by ripping them and fraying the edges a bit. Add text for the background of 1, 2 or all of the pages.

Add photos and journaling
Journal on a few scraps of painted canvas. Arrange your photos and scraps on as many pages as desired, then sew everything in place, using a sewing machine.

4

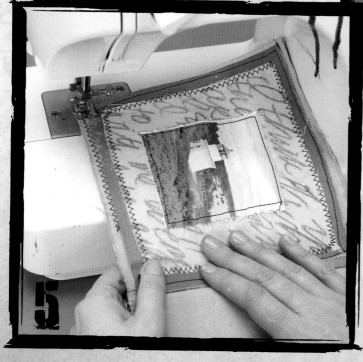

5

Sew more photos into book
When you turn the page, you'll notice that your stitching shows through on the following page. To prevent this from interfering with the next page's design, sew photos for the new page onto a piece of canvas slightly smaller than the book page. Then sew that piece onto the page in the book, stitching only around the outside.

Embellish cover

To decorate the cover of your book, sew a layer of photos and canvas scraps onto it, just as you did for the interior pages. Lay the book with the covers facing up and make a loop of hemp twine that extends the length of the back cover, adding a few inches (centimeters) to account for the thickness of the book and loop around a button. Sew the loop onto the center of the spine.

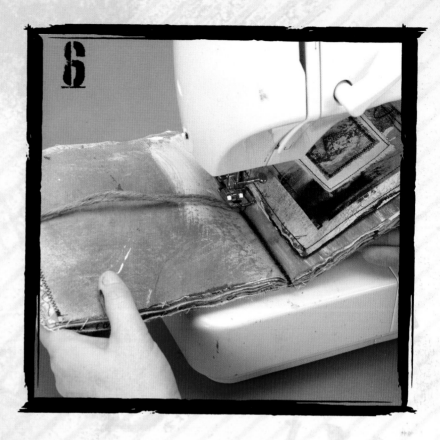

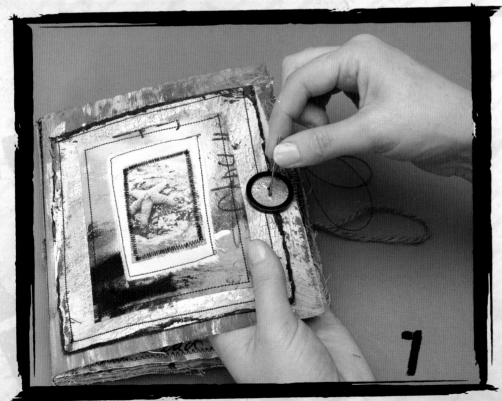

Add closure

Finally, sew a button to the right, center edge of the cover. Wrap the twine around the button to close.

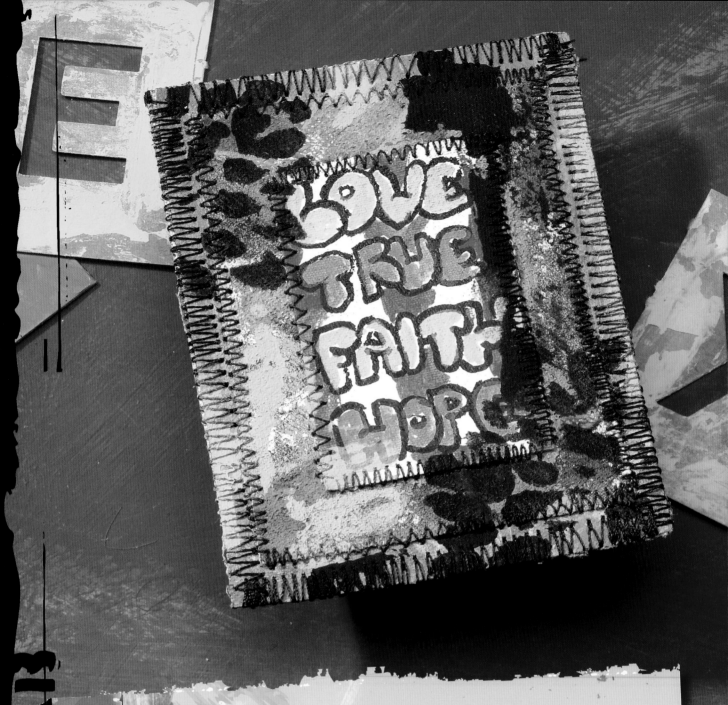

Graffiti ATC

The only requirement for an artist trading card is that it's 2½" × 3½" (6cm × 9cm). So the ideas for unique ATCs made from canvas are endless! When applying layers of stencils and text, you can achieve a funky urban look sure to create a one-of-a-kind ATC.

Materials

assorted scraps of painted canvas

acrylic paint (2 colors)

fine paintbrush

stencil brush

permanent marker

stencil

sewing machine

scissors

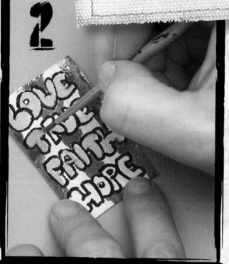

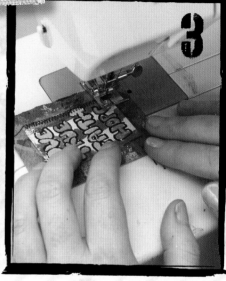

Cut canvas and journal

Cut 2 pieces of canvas to 2½" × 3½" (6cm × 9cm) and 2 more that are slightly smaller (1 smaller than the other). On the smallest piece, use a permanent marker to write bubble letters.

Paint letters

Color in the letters with acrylic paint and a fine brush. Let them dry.

Sew canvas together

Use the sewing machine to attach the lettered piece to the slightly larger scrap, using a zigzag stitch.

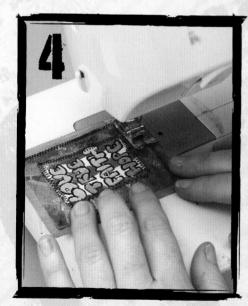

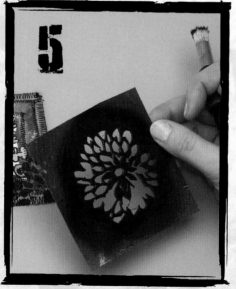

Attach to back piece

Sew these pieces to a 2½" × 3½" (6cm × 9cm) piece from step 1.

Apply stencil

Sew the final 2½" × 3½" (6cm × 9cm) piece to the back of the other, continuing around the perimeter. Use a stencil, stencil brush and acrylic paint to add interest to a couple of places.

Add brushstrokes

Finally, add a couple of strokes of color using a dry brush and a contrasting color of paint.

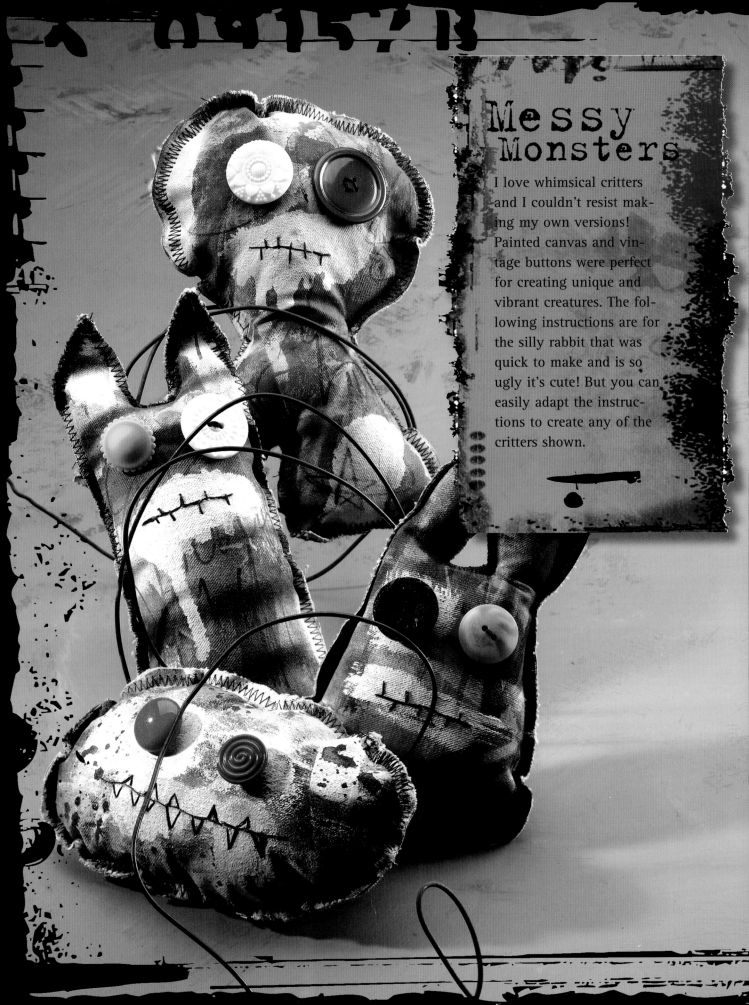

Messy Monsters

I love whimsical critters and I couldn't resist making my own versions! Painted canvas and vintage buttons were perfect for creating unique and vibrant creatures. The following instructions are for the silly rabbit that was quick to make and is so ugly it's cute! But you can easily adapt the instructions to create any of the critters shown.

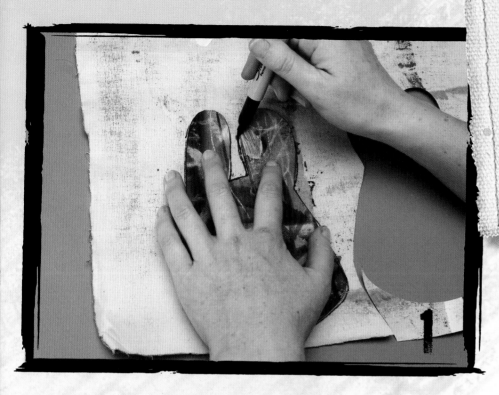

Materials

scrap of canvas painted
with brushstrokes and
spray-paint canvas

acrylic paint (white)

paintbrush

permanent marker

2 mismatched buttons

batting

needle

thread

sewing machine

scissors

Draw creature

Draw a somewhat random
monster shape on a piece of
canvas and cut it out with scissors. Flip the canvas so it is
wrong side up and use a permanent marker to trace the shape.

Create monster's second side

Set the piece you wish to be the
back aside. Lay both buttons over
the front piece where you want
to put the eyes. If there is little
contrast there, remove the buttons
and add a contrasting stroke or
shape of paint to the canvas where
the eyes will go. Add a stroke of
paint where the mouth will go. Let
it dry.

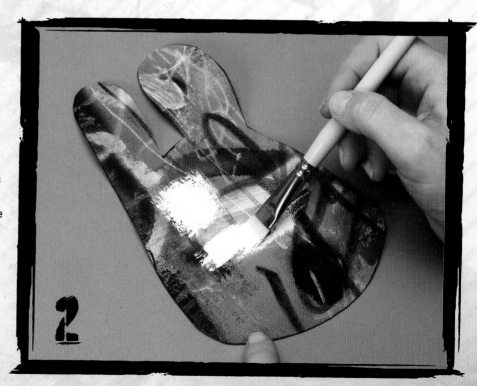

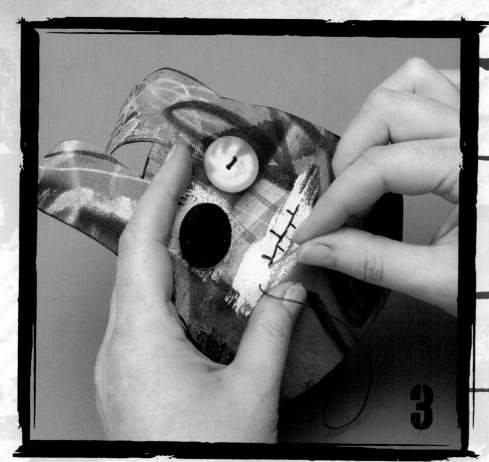

Add facial features
Sew on the button eyes and hand-stitch the mouth.

3

Sew sides together
With a sewing machine, stitch the front to the back, wrong sides together. Sew with a zigzag stitch along the edge, leaving about a 3" (8cm) opening at the bottom.

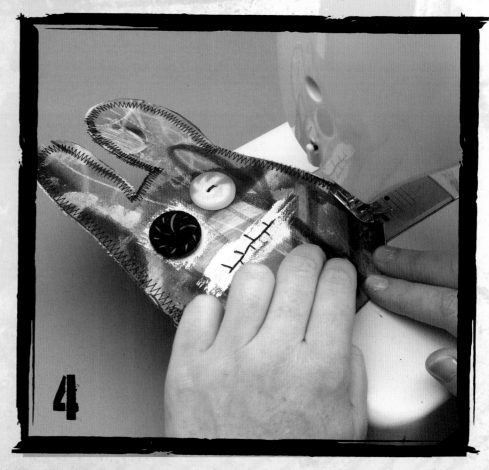

4

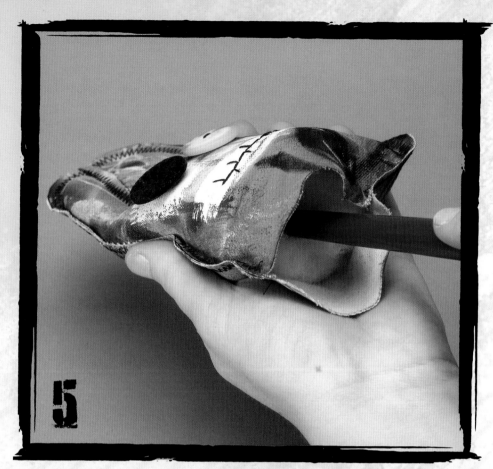

Stuff critter
Begin adding batting to the inside of the monster. Use the end of a paintbrush to force the stuffing into smaller areas such as ears or appendages.

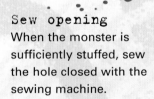

Sew opening
When the monster is sufficiently stuffed, sew the hole closed with the sewing machine.

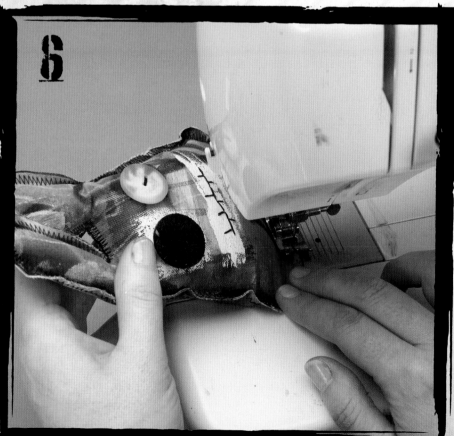

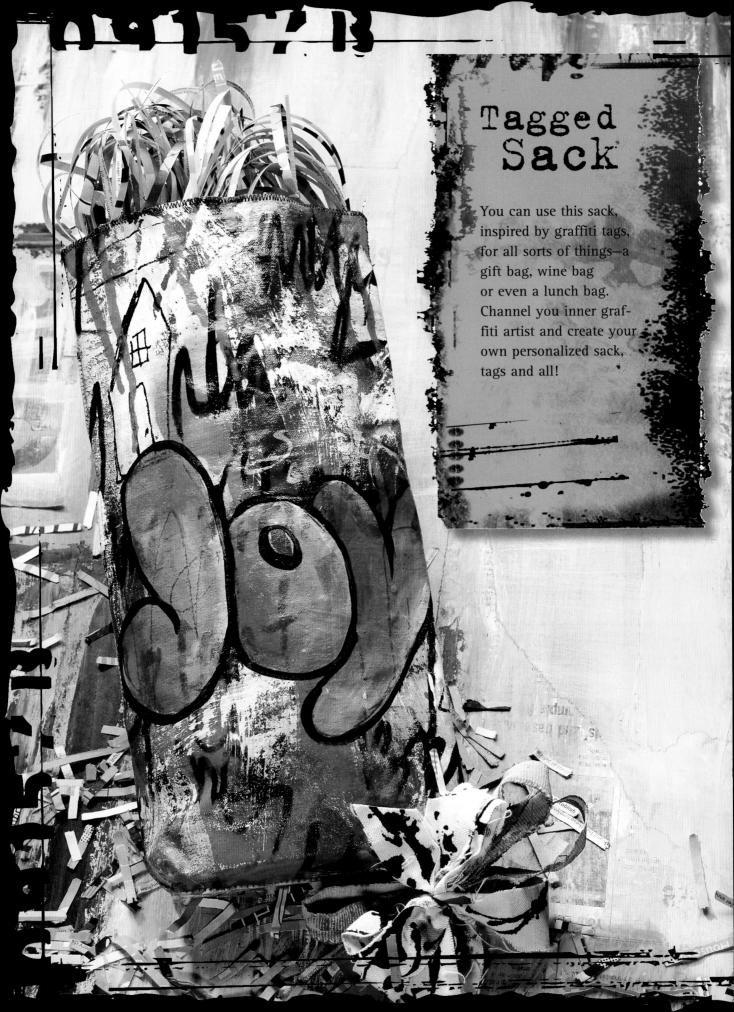

Tagged Sack

You can use this sack, inspired by graffiti tags, for all sorts of things—a gift bag, wine bag or even a lunch bag. Channel you inner graffiti artist and create your own personalized sack, tags and all!

Color-wash canvas and sew border

Cut 2 pieces of painted canvas to 7½" × 13" (19cm × 33cm), and apply a color wash to the back of each. Let them dry. Add a zigzag stitch to the top edge of each piece.

Sew canvas together

With the 2 right sides together, sew along the 2 sides and the bottom.

Materials

2 pieces of canvas with layers of painting techniques of your choice

acrylic paint

polyurethane

paintbrush

water cup

sewing machine

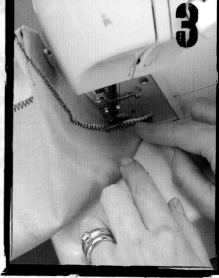

Create bottom

Fold the corners into triangles and make a straight stitch about 1" (3cm) from each point.

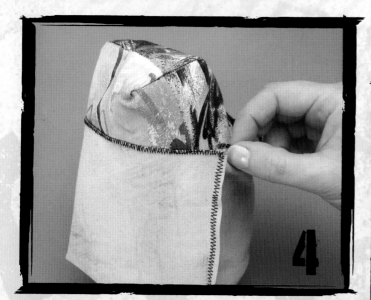

Turn sack

Turn the sack right-side out.

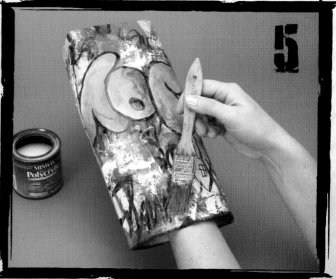

Seal sack

Apply a coat of polyurethane to the outside of the sack.

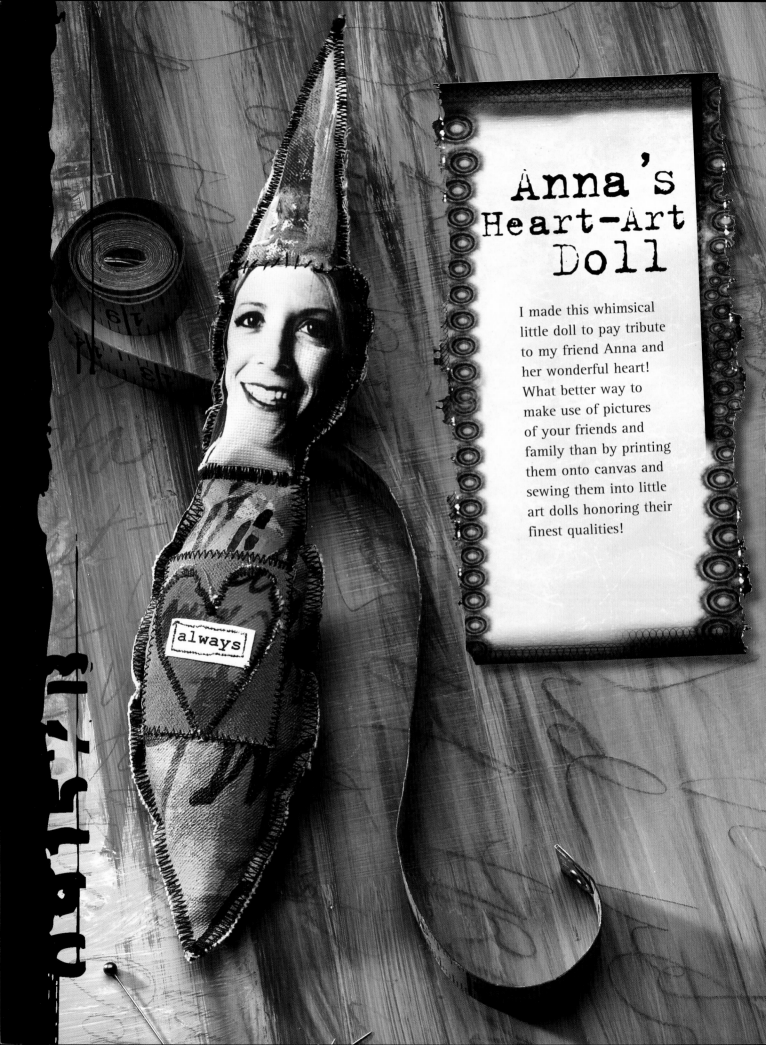

Anna's Heart-Art Doll

I made this whimsical little doll to pay tribute to my friend Anna and her wonderful heart! What better way to make use of pictures of your friends and family than by printing them onto canvas and sewing them into little art dolls honoring their finest qualities!

always

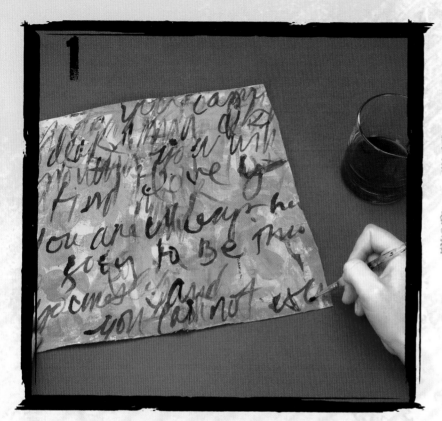

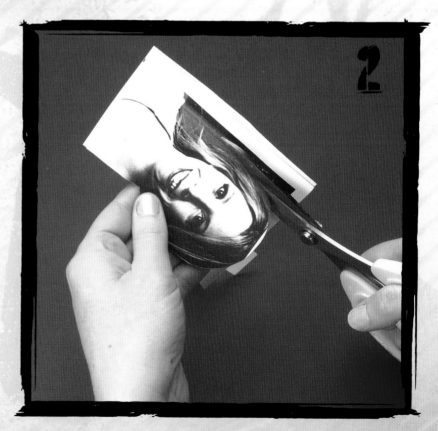

Materials

canvas painted with brushstrokes and stamps

2 solid-colored painted canvases

scrap of canvas painted in the style of your choice

ink-jet-compatible canvas sheet

word printed on canvas

fine paintbrush

acrylic paint (black)

water cup

batting

scissors

needle

thread

sewing machine

Journal on canvas

Consider the person who is the inspiration for the doll. Journal text that expresses your thoughts onto the piece of brushstroked and stamped canvas, using a liner brush and a wash of color.

Cut out photo

Print a portrait of your subject onto the printer-ready canvas sheet according to the manufacturer's instructions. With a blank piece of canvas that will be the back of the doll's head behind it, cut out the portion of the portrait you want to use.

3

Draw body and cut
Fold the journaled canvas in half. Leaving a neck portion at the edge, draw an almond-shaped body on the canvas. Cut out both pieces together with scissors.

Create heart
Take a rectangular piece of a solid-colored canvas and add some more journaling as you did in step 1. Then, cut a heart from the journaled piece of canvas.

4

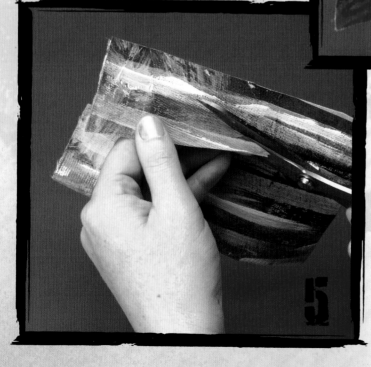

Create hat
Trim the word out of the sheet of canvas and also cut out 2 identical cone shapes from a scrap, to serve as a hat.

5

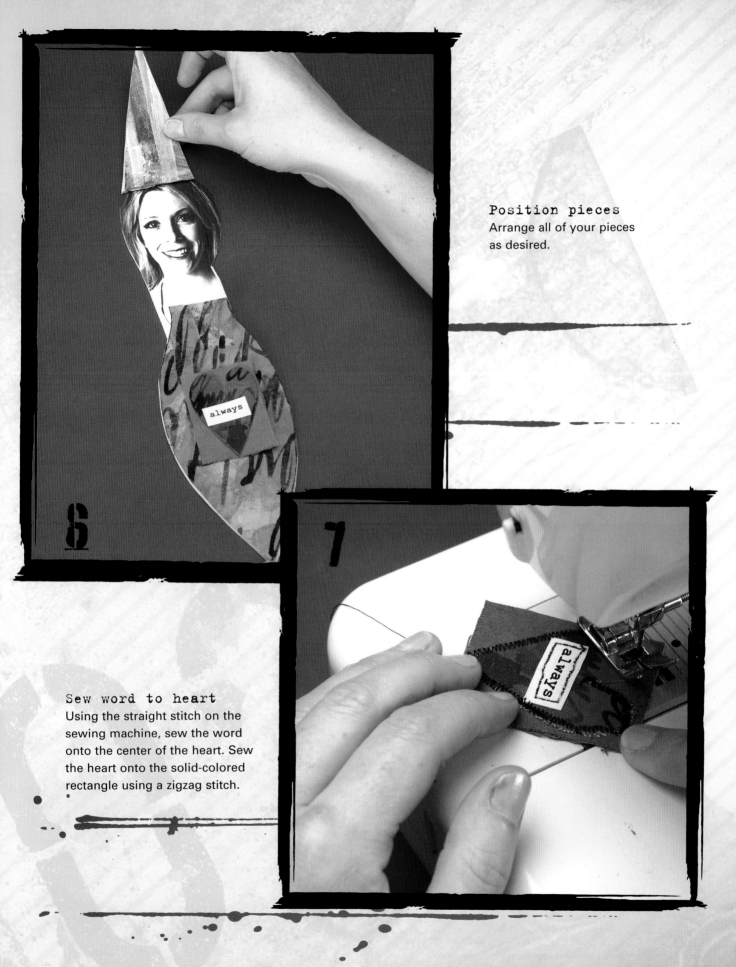

Position pieces
Arrange all of your pieces
as desired.

Sew word to heart
Using the straight stitch on the
sewing machine, sew the word
onto the center of the heart. Sew
the heart onto the solid-colored
rectangle using a zigzag stitch.

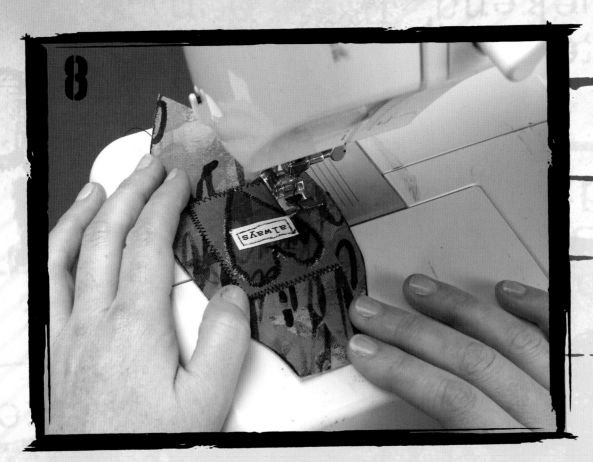

Attach heart to body
Sew the piece created in step 7 onto the front of the body.

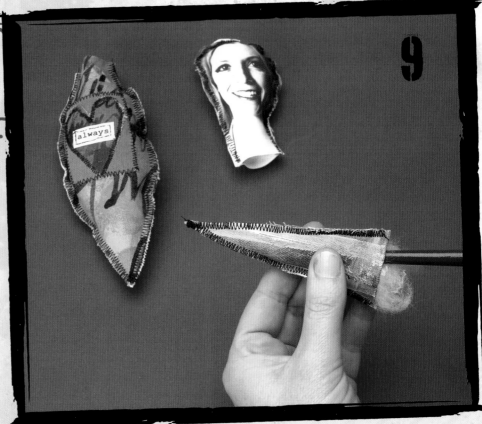

Sew and stuff body, head and hat
Sew the sides of the body together, leaving the neck side open. Sew the halves of the head together, leaving the neck edge open. Sew the hat together, leaving the bottom edge open. Stuff each of the pieces with batting.

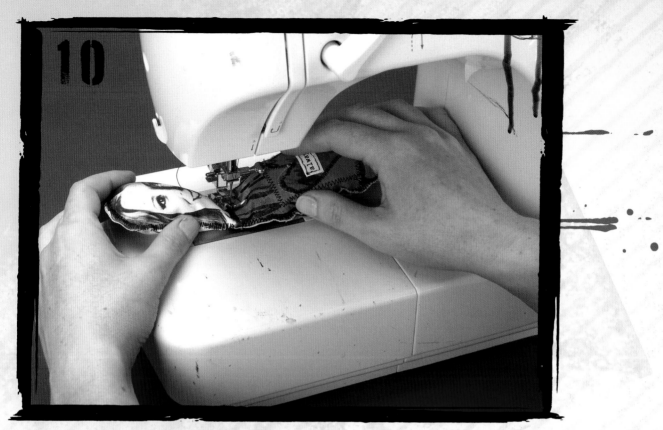

Attach head to body

Insert the neck of the head into the body and sew the pieces together using a sewing machine.

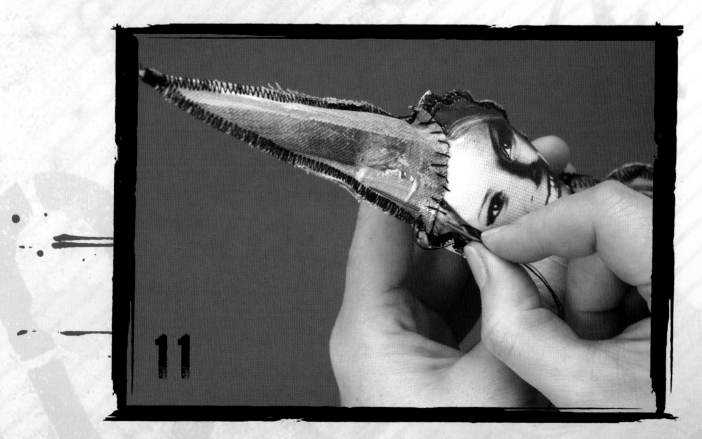

Attach hat to head

Finally, insert the top of the head into the hat and sew the pieces together by hand.

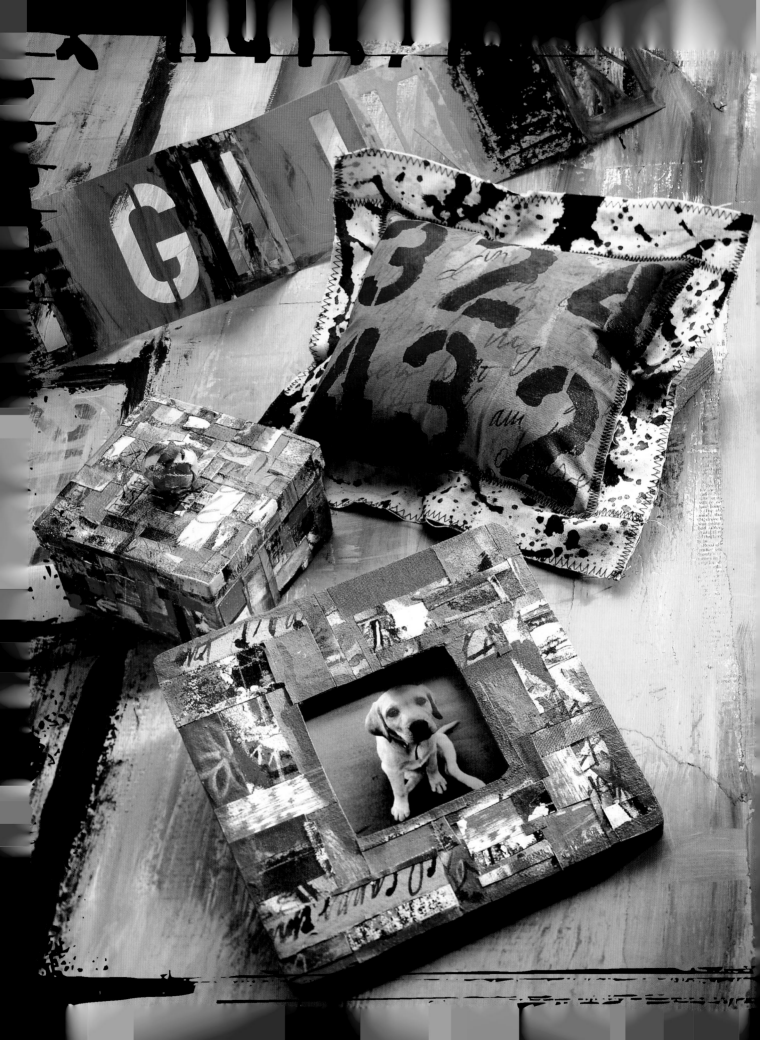

3

HOME REMIX

From the paint and artwork on my walls to the knickknacks on my coffee table, my home has always been an extension of who I am. It's important for me to be surrounded by things that express my personality and style and don't cost a lot. Through the years there have been times when I've lived on a tight budget, but my home still looked fabulous—I have my background in art to thank for that.

As a painter, I've been able to transform just about anything in my house. Canvas and paint are the perfect materials to use when creating home accessories that brighten and revamp your world. In this chapter, I hope to bring inspiration and some new ways to look at the things you put in your space. Like most of my ideas, many of these projects came from the need for something that I decided I'd rather create than purchase. They're just the beginning of the numerous artistic accessories you can create for your own domain.

Before you get started

- *Before buying new accessories for your home, figure out if there are things that you can make out of canvas and paint.*

- *Be brave with color! Make use of rich and vibrant colors in your creations to add a little punch to your space.*

- *Look for inspiration in design blogs and decorating magazines. Take your favorite ideas and try remixing your canvas into unique objects for your pad.*

- *Incorporate your personality into your domain. Use your initials as a monogram, incorporate travel photos into your canvas creations or use your favorite quotes in your projects.*

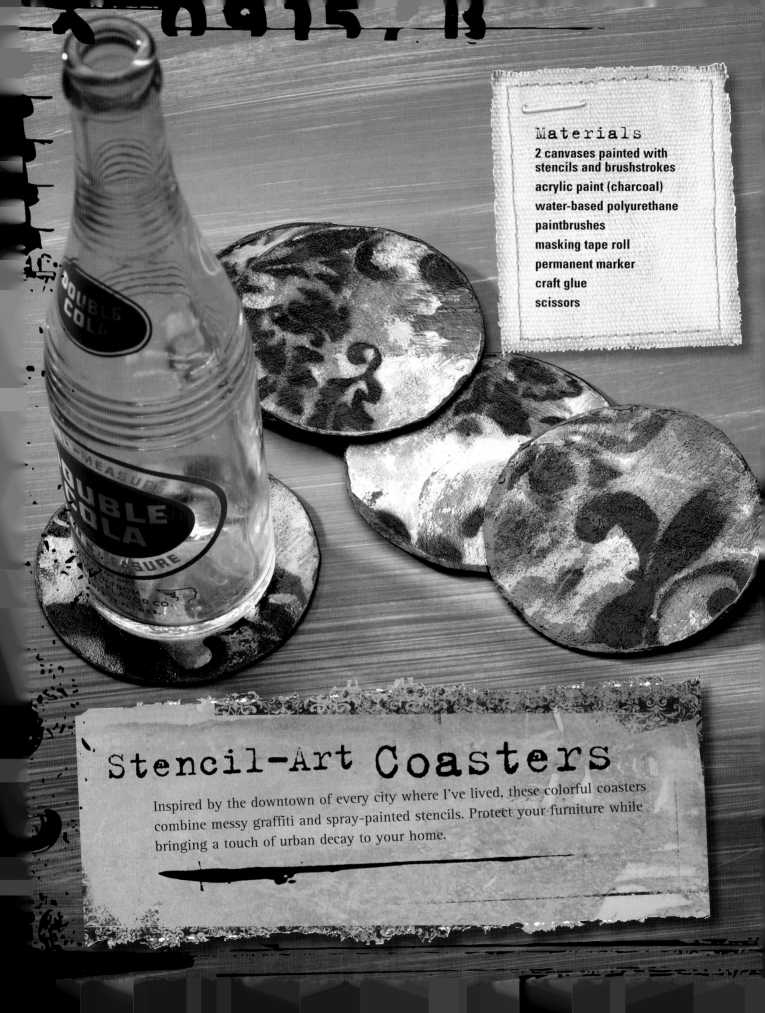

Materials

2 canvases painted with stencils and brushstrokes

acrylic paint (charcoal)

water-based polyurethane

paintbrushes

masking tape roll

permanent marker

craft glue

scissors

Stencil-Art Coasters

Inspired by the downtown of every city where I've lived, these colorful coasters combine messy graffiti and spray-painted stencils. Protect your furniture while bringing a touch of urban decay to your home.

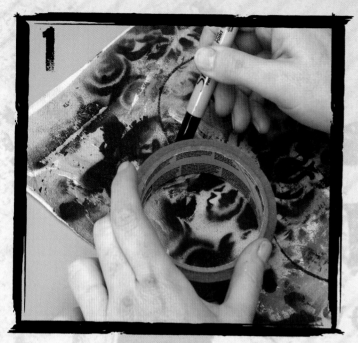

Trace shape

Using the craft glue, adhere 2 pieces of canvas together, back to back. Let it dry. Using a permanent marker, trace around a roll of masking tape to create circles on the canvas.

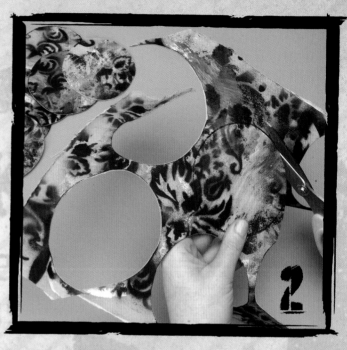

Cut circles from canvas

Use scissors to cut out the circles.

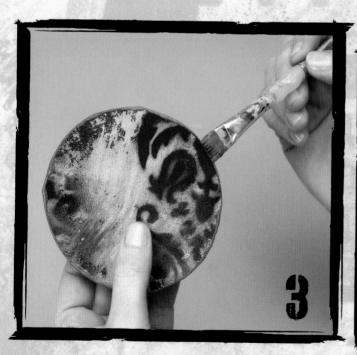

Paint edges

Use a brush to dab paint onto the edge of each coaster. Let them dry.

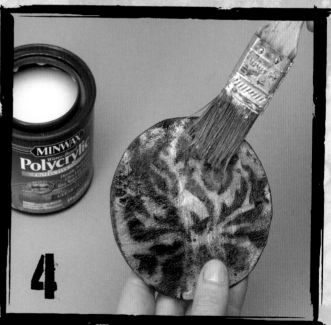

Seal coaster

Apply a coat of polyurethane to both sides of each coaster. Let them dry, then have a drink!

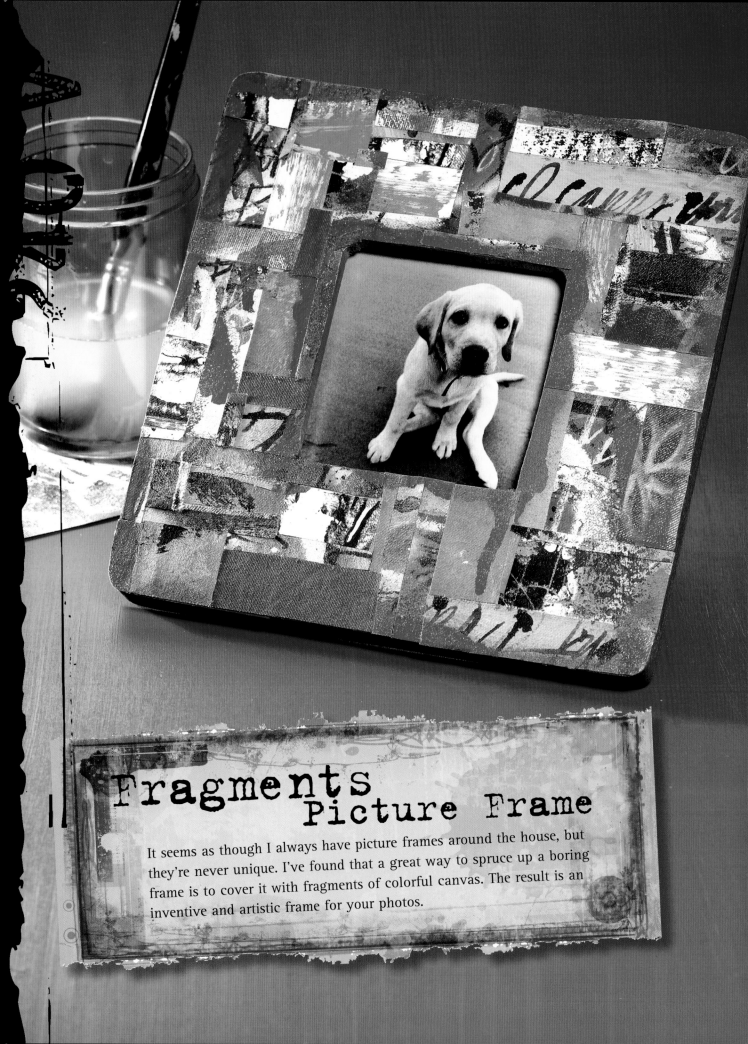

Fragments
Picture Frame

It seems as though I always have picture frames around the house, but they're never unique. I've found that a great way to spruce up a boring frame is to cover it with fragments of colorful canvas. The result is an inventive and artistic frame for your photos.

1

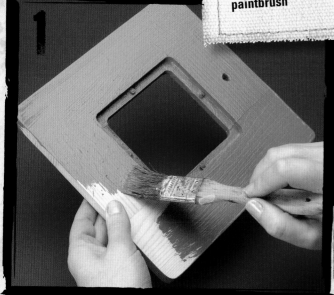

Paint frame

Paint the back, the image area and the sides of the frame in a color that complements your canvas scraps.

2

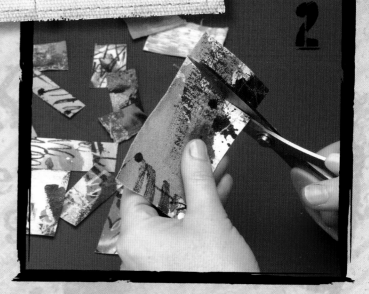

Create scraps of canvas

Cut your scraps into pieces that range in size from 1"–3" (3cm–8cm) in a variety of widths and lengths.

3

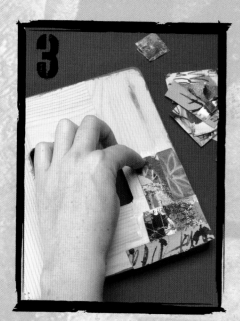

4

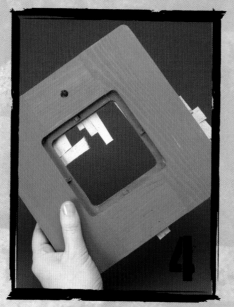

5

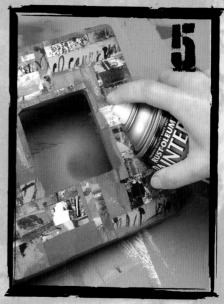

Glue scraps to frame

Begin gluing the pieces onto the front of the frame, overlapping the pieces as you go. It's OK if the pieces go over the edges; you can trim those off later.

Trim edges

Continue adhering the pieces until the front of the frame is covered. After the glue is dry, trim the pieces that run off the edges.

Apply spray paint

Spray paint the area around the image opening and around the outside of the frame. It's nice if it drips in places!

Yummy Patchwork Place Mat

Place mats are a great for enhancing a table setting. Create your own with graffiti words, bold colors and textures that will bring a little art to your meals!

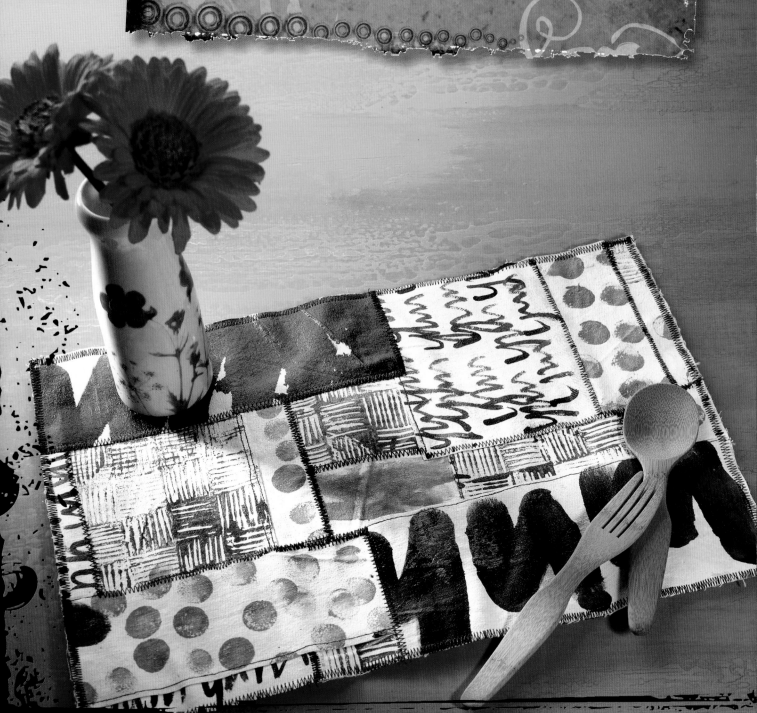

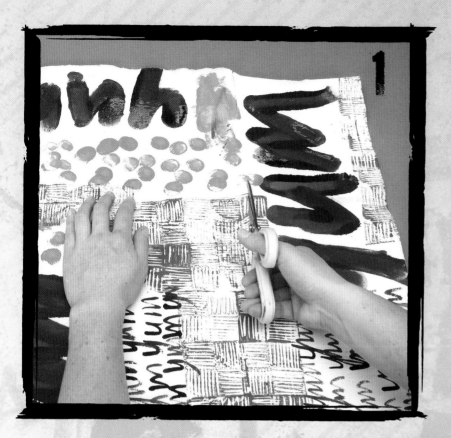

1

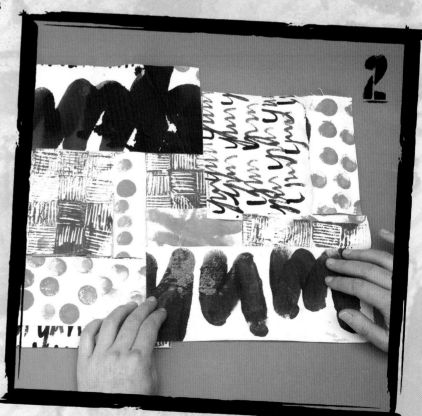

2

Materials

primed canvas

large piece of canvas painted with sponges

acrylic paint (1 color)

water-soluble polyurethane

paintbrushes

shoe polish

stamp

straight pins

sewing machine

scissors

Stamp and journal canvas

On a large piece of primed canvas, decorate some areas with paints and stamps and some with shoe-polish text. Cut the canvas into pieces for your patchwork.

Position canvas pieces

Lay out the cut pieces to decide how you'd like to sew them together. The overall layout should be slightly larger than the size you want your place mat to be, so you can trim the edges off later.

Sew pieces together

Pin all of the pieces together. Sew around each individual shape. Alternate the stitching so some shapes are bordered in zigzag stitch and some in straight stitch.

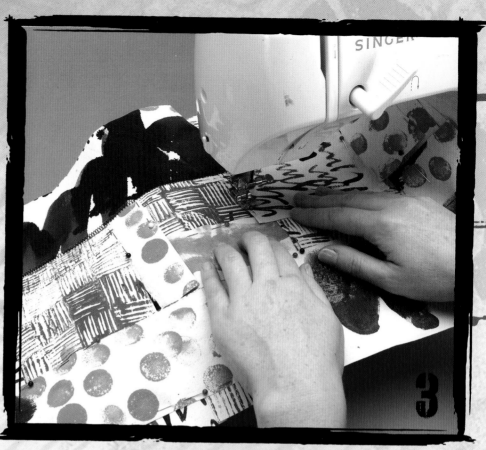

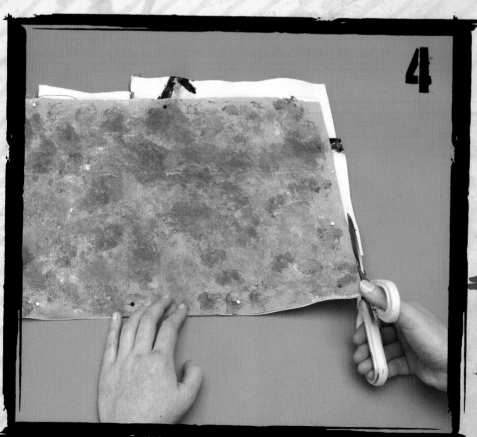

Trim canvas

Use scissors to trim the sponged canvas down to your desired size. Pin it to the back of the patchwork and trim away the excess canvas pieces.

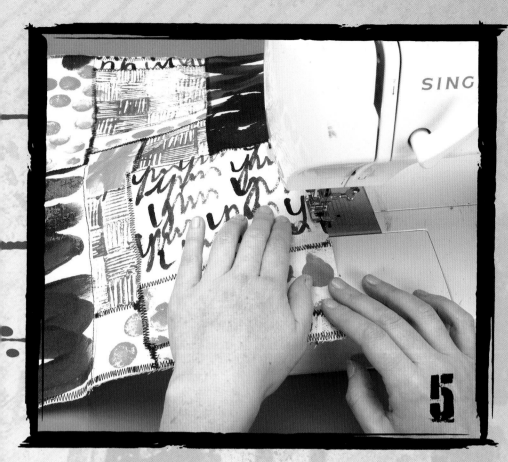

Sew together
Sew around the perimeter of the place mat with a zigzag stitch.

5

Seal place mat
Finally, brush the front of the place mat with a coat of polyurethane. Let it dry.

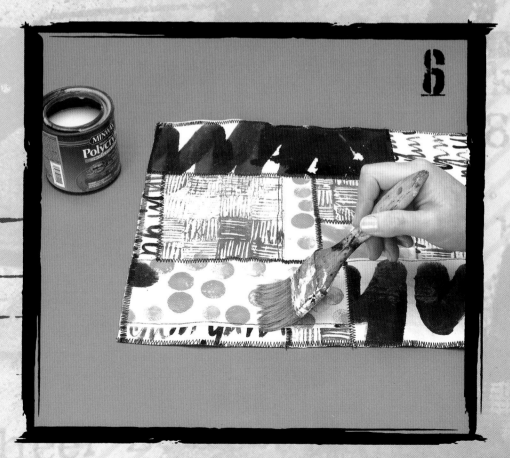

6

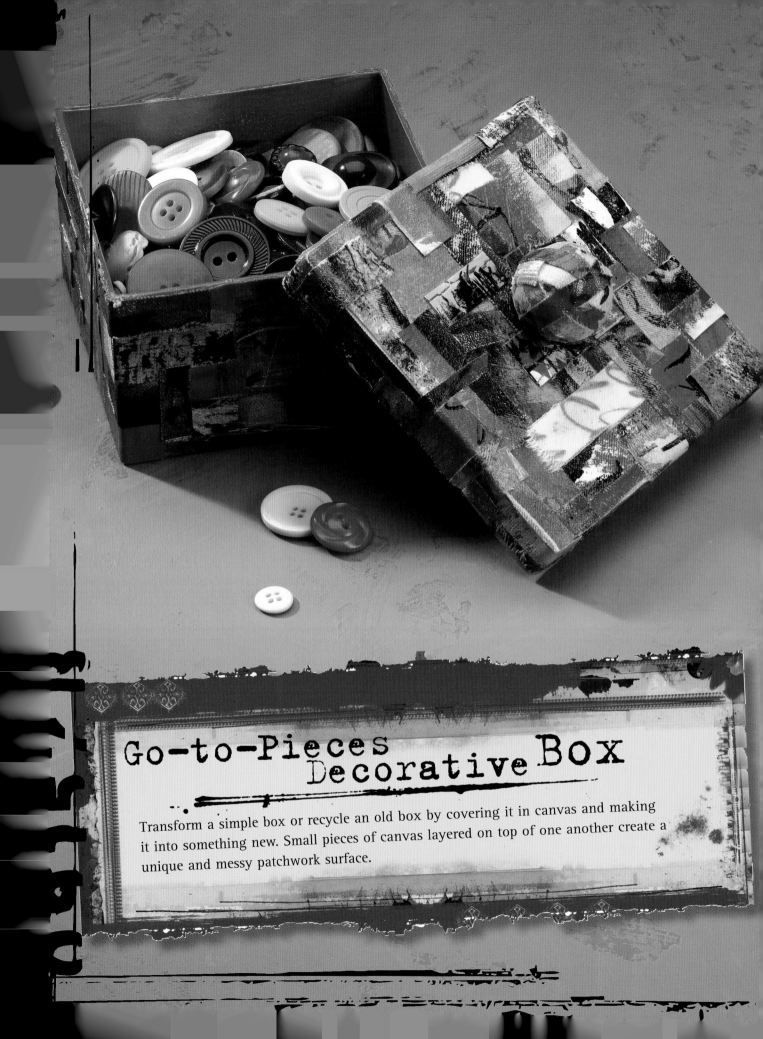

Go-to-Pieces Decorative Box

Transform a simple box or recycle an old box by covering it in canvas and making it into something new. Small pieces of canvas layered on top of one another create a unique and messy patchwork surface.

Materials

- scraps of painted canvas
- acrylic paint (1 color)
- water-based polyurethane
- paintbrushes
- paper box
- round wood knob
- scissors
- craft glue

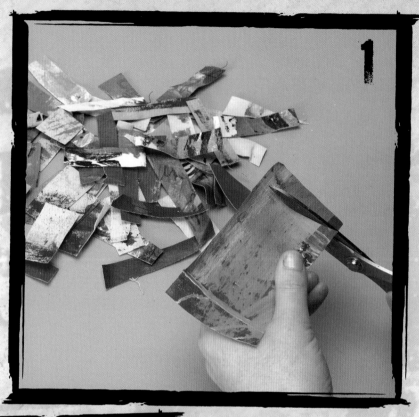

Cut canvas scraps

Use scissors to cut assorted canvas scraps into small strips.

Apply glue to box

Brush glue onto both sides of a box corner.

Glue canvas to box
Begin adhering the canvas strips to the box, overlapping some of them onto the middle strips.

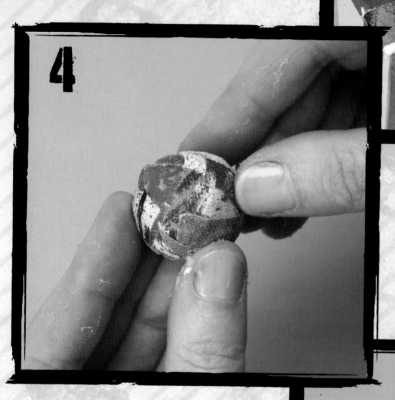

Cover lid and knob
Apply more glue as needed and continue applying strips until the box is covered. Then, repeat for the lid. Lastly, cover a wood ball with glue and canvas to be used as a knob for the lid.

Paint inside of box and lid
Paint the interior of the box and the lid with acrylic paint. Let it dry.

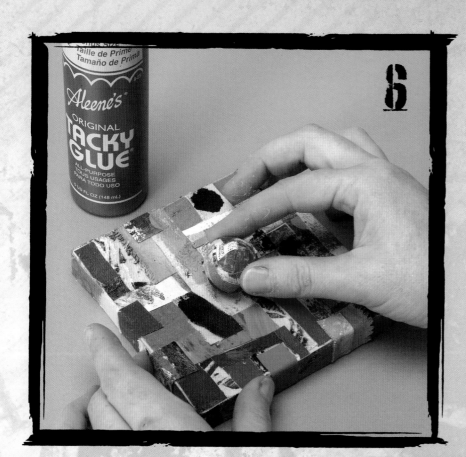

6

Attach knob

Using craft glue, adhere the covered knob to the top of the lid. Let it dry.

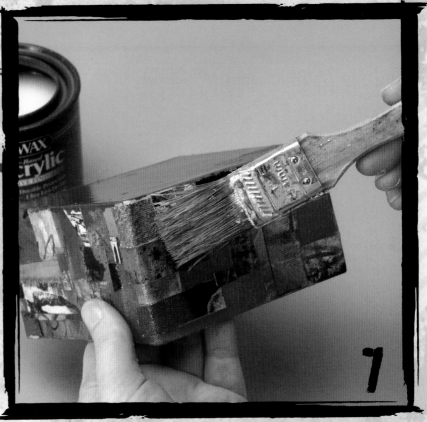

7

Seal box

Give the entire outside of the box a coat of polyurethane. Let it dry.

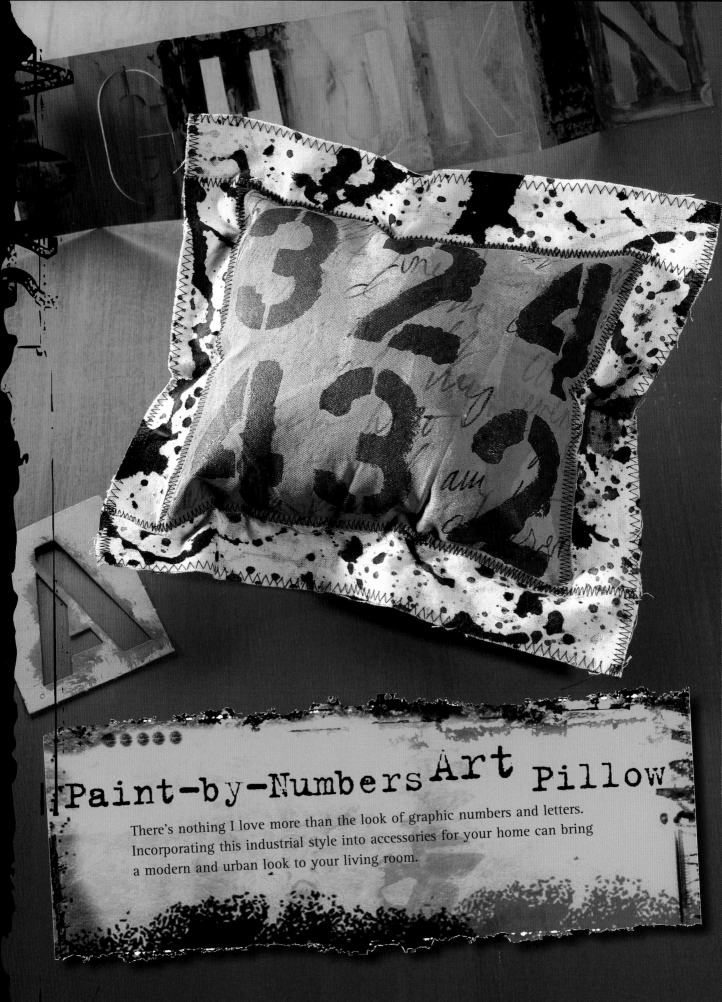

Paint-by-Numbers Art Pillow

There's nothing I love more than the look of graphic numbers and letters.
Incorporating this industrial style into accessories for your home can bring
a modern and urban look to your living room.

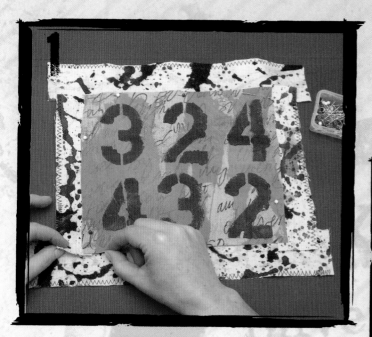

Materials

2 pillow-sized pieces of canvas painted with brushstrokes, stencils and marker text

unprimed canvas painted with splatters (2-sided)

batting

straight pins

sewing machine

scissors

Sew back piece

For the ruffle, cut the splatter canvas into 4 strips: 2 the length of the short side of the pillow pieces plus ½" (1cm) and 2 that are the length of the long side of the pillow pieces plus 1¾" (4cm) and each about 2" (5cm) wide. Sew a zigzag stitch along 1 long edge of each strip. Pin the ruffle strips and the pillow pieces together, with the ruffle between the 2 wrong sides of the pillow pieces, about ¼" (6mm) inside.

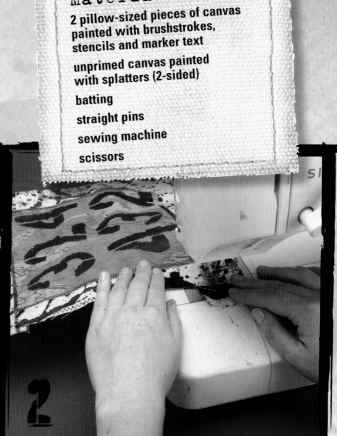

Sew ruffle

Use a zigzag stitch around the edge of the pillow pieces to simultaneously sew the halves together and attach the ruffle. Leave about 3" (8cm) of the edge unsewn to stuff the pillow later.

Trim ruffle

Using scissors, trim any areas of the ruffle that extend beyond the ends.

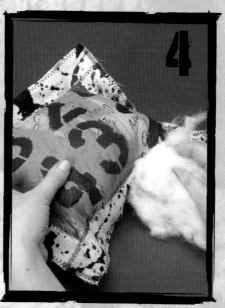

Stuff pillow

Sew a zigzag stitch where the ruffles overlap one another. Stuff the pillow.

Sew opening

Sew the final side closed with the sewing machine.

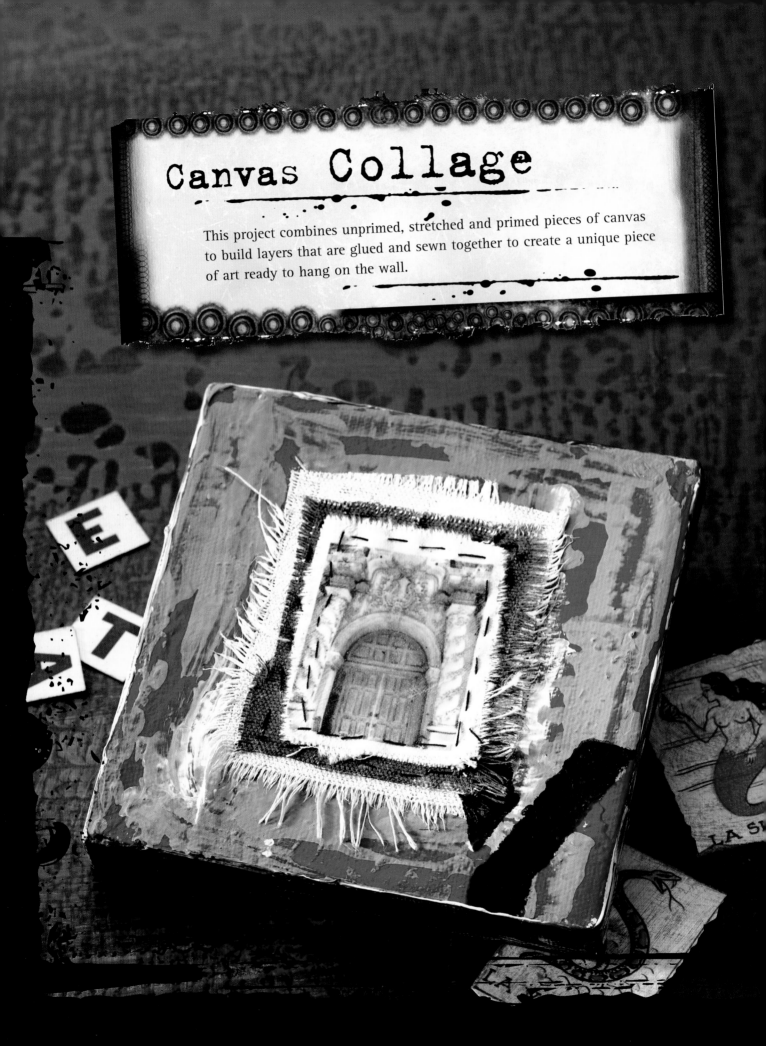

Canvas Collage

This project combines unprimed, stretched and primed pieces of canvas to build layers that are glued and sewn together to create a unique piece of art ready to hang on the wall.

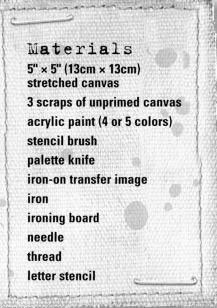

Materials

5" × 5" (13cm × 13cm) stretched canvas

3 scraps of unprimed canvas

acrylic paint (4 or 5 colors)

stencil brush

palette knife

iron-on transfer image

iron

ironing board

needle

thread

letter stencil

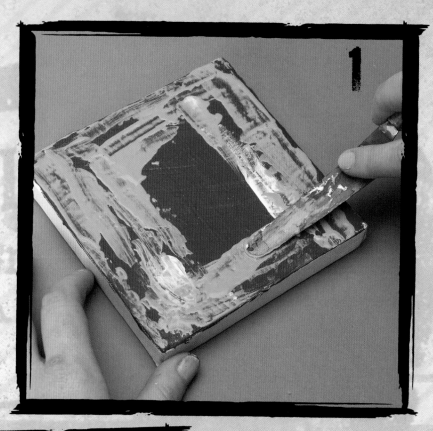

Paint canvas

Paint the front of the stretched canvas in a solid color and let it dry. Use a palette knife to add a contrasting color and a bit of texture over the base color.

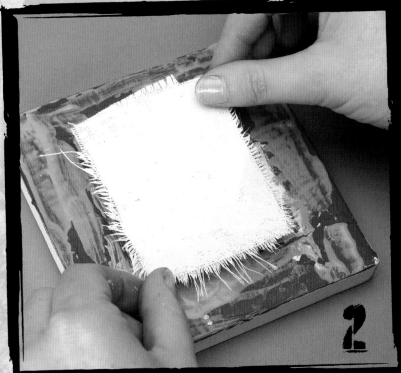

Apply canvas

While the paint is still wet, lightly press a piece of ripped, unprimed canvas into the surface. Let it dry.

Apply stencil

Position the stencil over part of the stretched canvas and part of the recently attached piece. Use a stencil brush and paint to add interest to that corner.

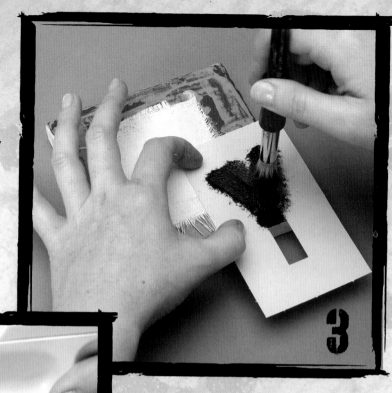

Iron transfer

Use an iron to transfer an iron-on transfer image onto a small piece of unprimed canvas.

Tear canvas to fit

Tear the canvas down to the size of the image and fray the edges a bit.

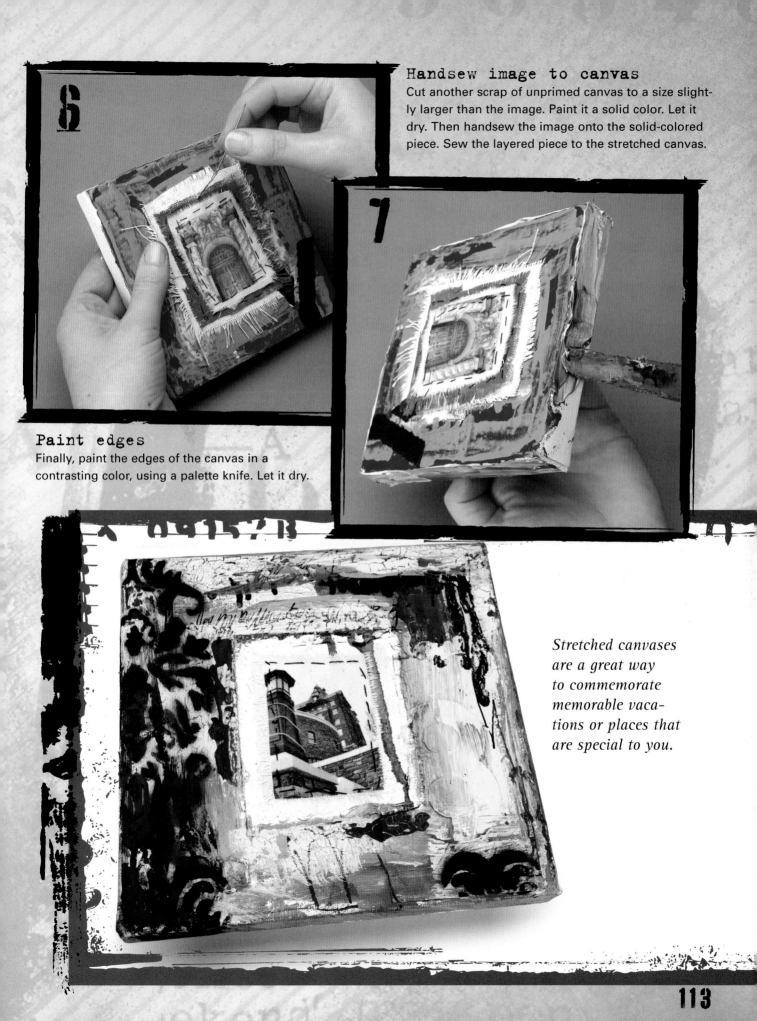

Handsew image to canvas

Cut another scrap of unprimed canvas to a size slightly larger than the image. Paint it a solid color. Let it dry. Then handsew the image onto the solid-colored piece. Sew the layered piece to the stretched canvas.

Paint edges

Finally, paint the edges of the canvas in a contrasting color, using a palette knife. Let it dry.

Stretched canvases are a great way to commemorate memorable vacations or places that are special to you.

Bits
and
Pieces
Ornaments

Another great way to make use of all those bits and pieces of leftover canvas is to create ornaments. Adapted from the concept of fabric-wrapped ornaments, this project uses pieces of graffiti and journaled canvas to create an offbeat decoration.

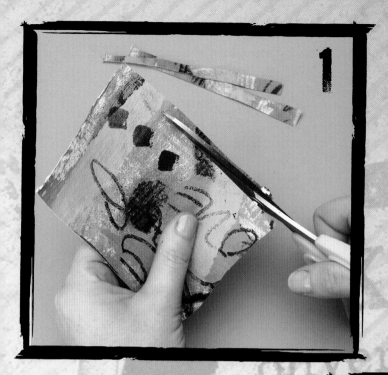

1

Cut canvas scraps
Cut strips from the canvas scraps.

Glue strips to ball
Use a brush to apply glue to the Styrofoam ball, and begin gluing on strips, alternating the text strips with the colored strips. Overlap the strips slightly as you adhere them.

Materials
scraps of canvas painted with text

scraps of canvas painted in various styles with a dominant coordinating color

Styrofoam ball

4 canvas beads

4 wood beads

16" (41cm) silk cord

tapestry needle

craft glue

paintbrush

scissors

awl

pliers

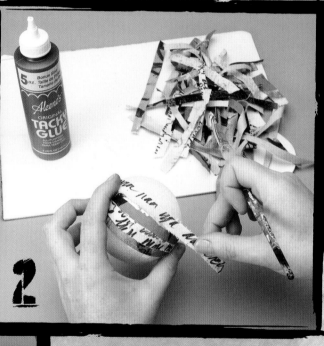

2

3

Thread canvas strip through ball
From a colored scrap, cut a strip that is about 24" (61cm) long and about ⅜" (1cm) wide. Thread the tapestry needle with the strip. Use an awl to create a path for the needle that goes completely through the ball.

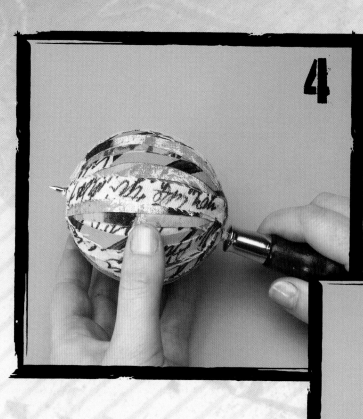

4

Pull strip through ball

Insert the needle at the end of the ball and pull the strip through to the other end. (You might need to use pliers or the awl to push the needle through.)

Create loop

Leaving a loop about 4" (10cm) long, push the needle back through the hole to the end where you started.

5

6

Knot loop

Tie a knot at the base of the loop and at the base of the loose ends.

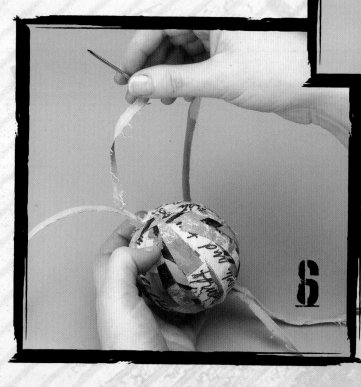

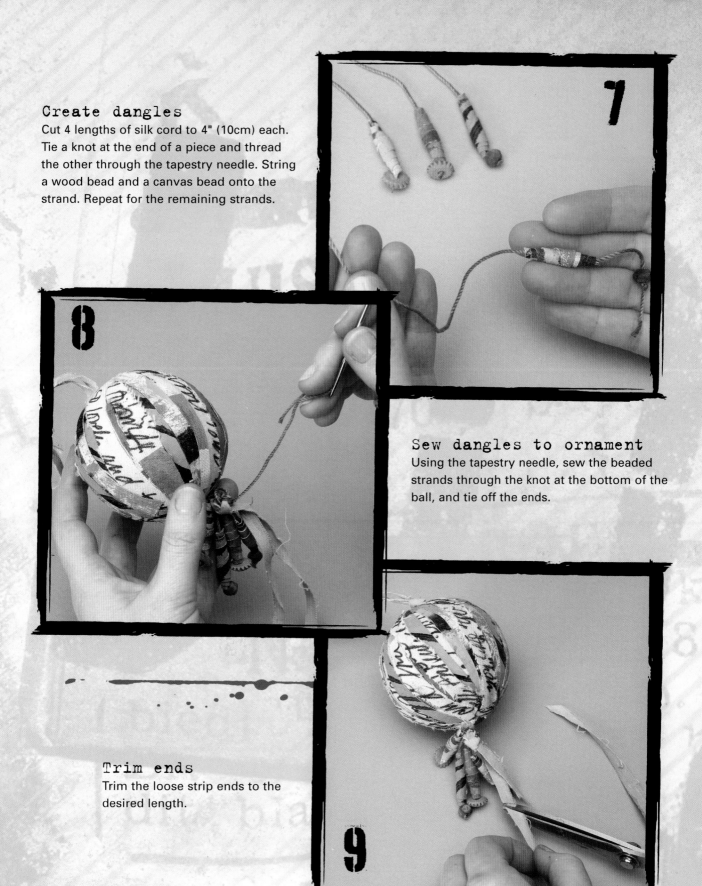

Create dangles

Cut 4 lengths of silk cord to 4" (10cm) each. Tie a knot at the end of a piece and thread the other through the tapestry needle. String a wood bead and a canvas bead onto the strand. Repeat for the remaining strands.

Sew dangles to ornament

Using the tapestry needle, sew the beaded strands through the knot at the bottom of the ball, and tie off the ends.

Trim ends

Trim the loose strip ends to the desired length.

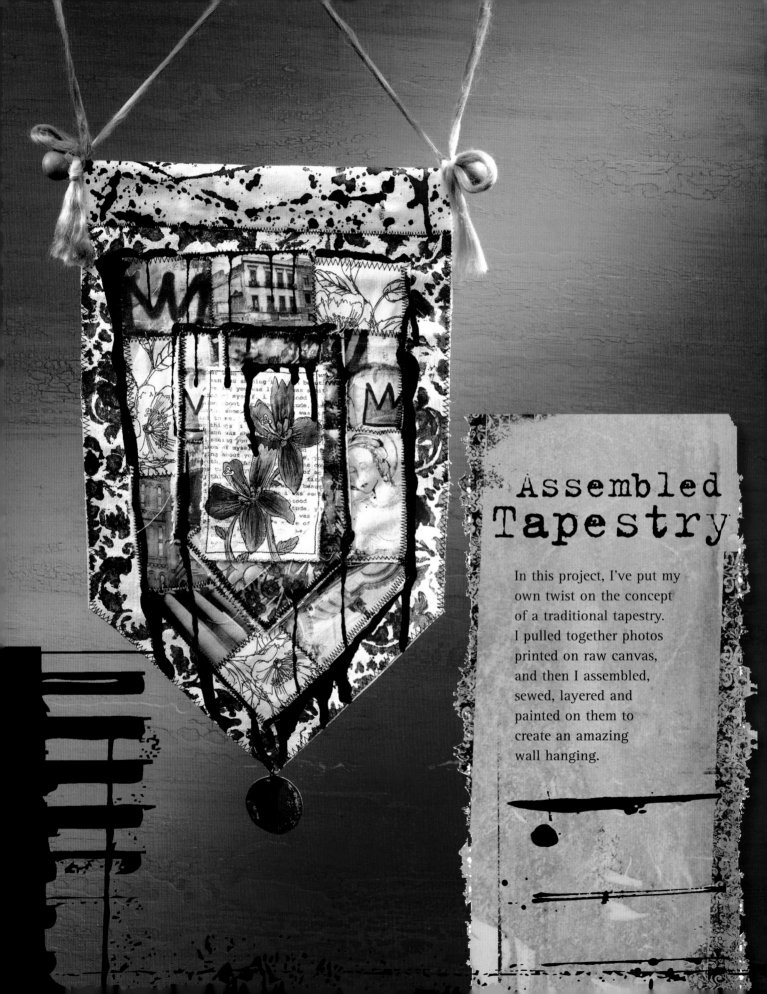

Assembled Tapestry

In this project, I've put my own twist on the concept of a traditional tapestry. I pulled together photos printed on raw canvas, and then I assembled, sewed, layered and painted on them to create an amazing wall hanging.

Materials

- primed canvas
- unprimed canvas
- canvas painted with splatters
- small painted canvas scraps
- assorted colors of acrylic paint
- paintbrush
- condiment bottle
- stencil
- photo printed on canvas
- stencil brush
- gel medium
- page of typed text
- dowel
- 2 knobs
- straight pins
- jump ring
- awl
- pliers
- craft glue
- scissors
- sewing machine

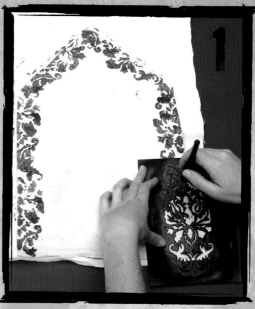

Apply stencil to canvas

Cut out a piece of primed canvas to the size you want your wall hanging to be. Here, I cut a banner shape that is about 12" × 15" (30cm × 38cm). Stencil the first color of paint in a border around the piece that's about 1½" (4cm) wide.

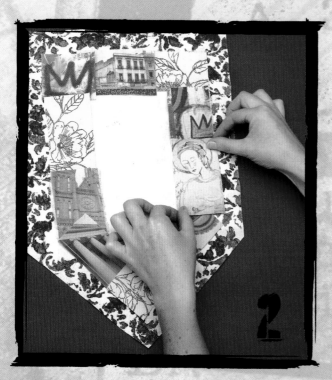

Position photos

Cut out the banner frame created in step 1. Cut out the photos printed on canvas and lay them out on your canvas.

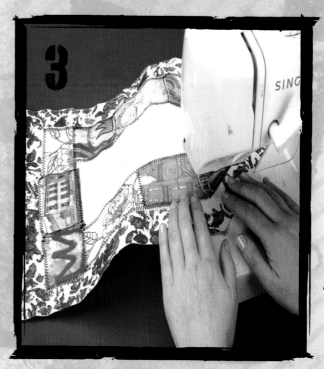

Sew photos to canvas

Pin all of the photos in place. Begin sewing them down, starting with a continuous line around the outside, in a zigzag stitch. Then, sew along the perimeters of the remaining sides of each image.

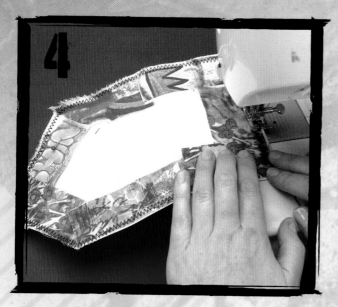

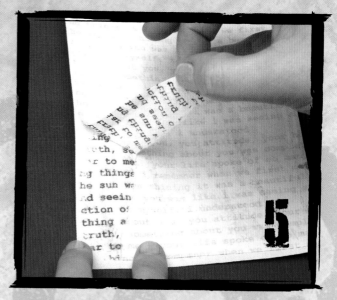

Create a smaller banner

Repeat steps 1–3 creating a smaller proportionately sized banner using primed canvas. For the photos, you can use new ones or pieces you didn't use for the larger banner.

Transfer text

On a piece of primed or painted canvas, use gel medium to transfer a block of text.

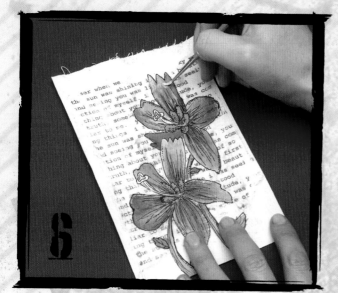

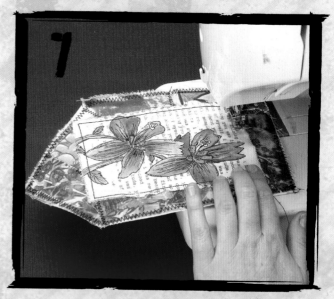

Apply image to transfer

On top of the photo transfer, you can paint an image, add an iron-on transfer or sew something as a focal point. Here, I've chosen to paint some flowers.

Sew transfer to canvas

Rip the piece to fit inside the center of the smaller banner created in step 4. Sew the piece down with a straight stitch, using a sewing machine.

Sew pieces together

Sew this piece to the main piece, using a zigzag stitch.

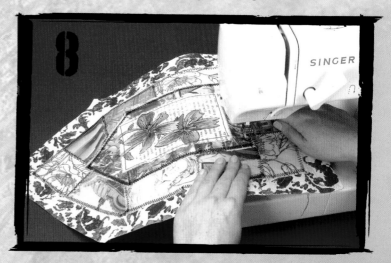

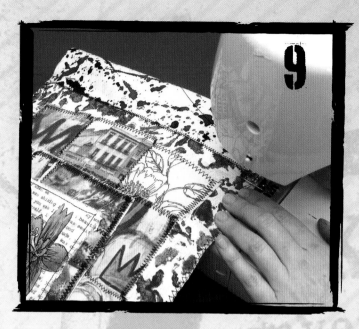

Attach back piece

For extra stability—and to hide your stitches—sew a solid piece of canvas (any type) to the back as a lining, using a zigzag stitch. Cut a piece from the paint-splattered canvas that's the width of the hanging and about 4" (10cm) long and fold it in half. Sandwich the top of the hanging inside the paint-splattered canvas, with the canvas overlapping the hanging on both sides by about ¼" (6mm). Sew the pieces togetherwith a zigzag stitch.

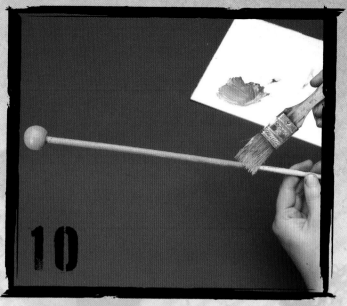

Paint dowel

Glue the knobs to the ends of the dowel and then paint the entire piece with a color that complements your hanging. Note: If your knobs are too large to fit through the channel at the top of the hanging, paint them separately and glue them on after the dowel is through the channel.

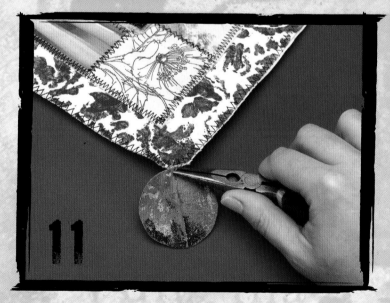

Insert dowel and add embellishment

When the dowel is dry, insert the knobs and dowel through the channel. Glue 2 scraps of painted canvas together, back to back, and cut a circle shape out of the canvas. Paint the circle a color or pattern that matches the dowel, and let it dry. Use an awl to make a hole at the top of the circle and a hole at the point in the hanging. Attach the circle to the point with a jump ring.

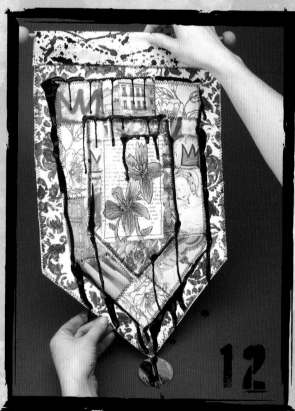

Scribble paint on surface

Squeeze black paint over some areas of the hanging with a condiment container. Then, hold the piece up to let the paint drip. Let it dry.

121

RESOURCES

Supplies

Dick Blick
Stretched and unstretched canvas, ink-jet canvas sheets
Blick Art Materials
P.O. Box 1267
Galesburg, IL 61402
(800) 723-2787
www.dickblick.com

Golden Artist Colors
Acrylic paint, mediums
Golden Artist Colors, Inc.
188 Bell Road
New Berlin, NY 13411
(800) 959-6543
www.goldenpaints.com

Krylon
Spray paint
(800) 457-9566
www.krylon.com

Montana
Spray paint
www.mtncolors.com

Minwax
Polyurethane
Minwax Company
10 Mountainview Road
Upper Saddle River, NJ 07458
(800) 523-9299
www.minwax.com

Plaid
Acrylic craft paint
(800) 842-4197
www.plaidonline.com

Sharpie
Permanent markers, paint markers
Sanford Corporation
Attn. Consumer Affairs
2707 Butterfield Road
Oak Brook, IL 60523
(800) 323-0749
(800) 668-4575, ext 4072 in Canada
www.sharpie.com

Magazines

American Craft
72 Spring Str.
6th Floor
New York, New York 10012
(212) 274-0630
www.americancraftmag.org

ARTnews
48 W. Thirty-eighth St.
New York, NY 10018
(800) 284-4625
+1-850-682-7644 (outside United States)
www.artnewsonline.com

Cloth Paper Scissors
Quilting Arts
P.O. Box 469087
Escondido, CA 92046
(800) 406-5283
www.quiltingarts.com/cpsmag/cpshome.html

Domino
P.O. Box 37760
Boone, IA 50037
(877) 356-9904
www.dominomag.com

Fiberarts
201 E. Fourth St.
Loveland, CO 80537
(800) 875-6208
www.fiberarts.com

Juxtapoz
1303 Underwood Ave.
San Francisco, CA 94124
(888) 520-9099
www.juxtapoz.com

New American Paintings
The Open Studios Press
450 Harrison Ave. #304
Boston, MA 02118
(617) 778-5265
www.newamericanpaintings.com

Books

Abstract Expressionism:
Other Politics
by Ann Eden Gibson (Yale University Press)

Art Against the Odds: From Slave Quilts
to Prison Paintings
by Susan Goldman Rubin (Crown Publishers)

The Art of Rebellion: The World of Street Art
by Christian Hundertmark (Gingko Press)

The Birth of Graffiti
by Jon Naar (Prestel Publishing)

Jean-Michel Basquiat
by Richard Marshall
(Whitney/ Museum of American Art)

Punk Diary: The Ultimate Trainspotter's
Guide to Underground Rock, 1970–1982
by George Gimarc (Backbeat Books)

Street World: Urban Culture
and Art from Five Continents
by Roger Gastman, Caleb Neelon and
Anthony Smyrski (Abrams)

Wall and Piece
by Banksy (Random House UK)

INDEX

About
the Author

Alisa Burke is a freelance painter and mixed-media artist who studied fine art at Portland State University, with a major in painting and printmaking. With a background in painting and a desire to explore and push the boundaries of materials, Alisa is always looking for new ways to break the rules and redefine art. She draws inspiration from street art, graffiti, art history and fashion. Alisa's paintings have been exhibited in a variety of galleries, and her artwork has been featured in publications such as *Cloth Paper Scissors*, *Somerset Studios' Haute Handbags*, *Art Doll Quarterly* and *University of San Diego Magazine*. In addition to making art, Alisa teaches a variety of workshops at the University of San Diego and local high schools as well as craft and art venues on the West Coast. Alisa has also appeared as a guest artist on the DIY Network show *Craft Lab*.

JOURNAL REVOLUTION

Linda Woods and Karen Dinino

Overthrow your inner critic's tyranny of fear and rules and discover fresh techniques and inspiration to rant, whisper, beg, stomp or sing your truths. Celebrate your rough edges with a revolutionary new approach to art journaling, as you learn to vividly express your uncensored emotions and boldly record your deepest secrets.

ISBN-10: 1-58180-995-6
ISBN-13: 9 781581 809954
paperback 128 pages
Z0950

ALTERNATION

Shannon Okey and Alexandra Underhill

AlterNation is the DIY fashion bible that shows you how to personalize your wardrobe with a wide range of sewing and embellishing techniques. Step-by-step instructions teach you how to make tie skirts, scrap scarves and much more. Soon be a total pro at making your own clothing and accessories.

ISBN-10: 1-58180-978-6
ISBN-13: 978-1-58180-978-7
paperback 144 pages
Z0713

PLUSH YOU!

Kristen Rask

Plush You! invites you into a world of more than 100 lovable—in a three eyes, ten arms, USO (unidentified stuffing object) sort of way—handmade toys to sew and stuff. Packed with inspiration from more than 90 plush artists from around the world, and complete with step-by-step instructions for making 15 unique projects, *Plush You!* will inspire you to replicate these quirky creations or invent one of your own.

ISBN-10: 1-58180-996-4
ISBN-13: 978-1-58180-996-1
paperback with flaps 144 pages
Z0951

COLLAGE UNLEASHED

Traci Bautista

Learn to collage using everything but the kitchen sink with this bright and playful book. Author Traci Bautista shows you there are no mistakes in making art. You can combine anything—paper, fabric, paint and even paper towels and beads, metal, doodles and stitching to create unique art books, fabric journals and mixed-media paintings.

ISBN-10: 1-58180-845-3
ISBN-13: 978-1-58180-845-2
paperback 128 pages
Z0024